PAINTING the Sacred Within

Art Techniques to Express Your Authentic Inner Voice

Faith Evans-Sills and Mati Rose McDonough

NORTH LIGHT BOOKS
CINCINNATI, OHIO
www.artistsnetwork.com

Contents

Introduction

Who Are You Becoming

Dear creative soul,

We thank you wholeheartedly for picking up this book, and we applaud your desire to begin this creative journey. We honor you for investing in your dreams and your painting practice! We want to do this work deep in our bones and help you soar.

Let's start thriving today as artists, diving into the deepest parts of our creativity together, shall we?

We are so excited to invite you inside our creative process! We incubated the idea for this book after an inspiring phone chat about what we really wanted for the year ahead. We both said that we wanted to paint alongside others for community, accountability and inspiration. So *we decided to create what we most needed*, in the hopes that others would find value in it, too. At first it was a year long e-course, and then it grew into international art retreats in Costa Rica and Morocco!

After two years of working together with women through these retreats and e-courses, we're overjoyed that we have seen so much growth in ourselves *and* our participants! It's incredible what can happen when people set the intention of making time for their studio practice to grow in a sustained way.

With more than twenty years each of personal painting experience, we've learned so much that we are eager to share with you, including what has and hasn't worked for us and how to come up with your own dynamic way of operating in your studio. Ultimately this is about your relationship to your work, the healthy habits that you develop in the studio, the ways in which you go about creating your art and the manner in which you access and sustain your most creative self—which in the end comprise a soul-satisfying studio practice making work you love!

There is a quote by author Karen Lamb that resonates with us so much: *A year from now you will wish you had started today.*

Applying this to our art practices we see how small changes built up over time will take your work in the direction you want it to go. We want to give you all the skills you need to make your work shine! THE TIME IS NOW.

Although we are ever changing, evolving, shaping and transforming, we believe that a continuous thread runs through all of our work. The longer we work, the more we understand there are steadfast approaches of helping ourselves jump into our process more easily. Our goal is not to create resolutions, but rather to help you create new rhythms of working that allow space for transformation. Art making is a practice, requiring daily attention to receiving, perceiving and responding. Are you hungry for more?

As with any practice, it requires you to make space in your life to nurture it to grow. Waste not a single moment more holding back for fear of expressing yourself. Say what you need to say, paint what you need to paint, create it now. As with anything in your life that is important to cultivate, allow yourself room to grow.

Deepen your practice through rest and connection. It's in quietness and trust that we often find our greatest treasures. This will mean something different to each of us. For you it might mean withdrawing into the beauty of nature or the quiet of your studio. Schedule regular silence and solitude. Outside, everything often whispers inspiration's name. In this book we invite you into exercises that will help you discover the best way into your art. The muse wants you to approach.

Create Beauty
Give Love
Find Peace
In the end, what is important is who we are becoming.
This book is your invitation to make space and dive into *Painting the Sacred Within*. Let us begin.

With wishes for so much blessed inspiration,

Faith & Mati

Basic Materials

We use a variety of mixed media, but here is a list of the basic supplies that we always have in our studios. Once you are in tune with scouting your supplies, you will see creative possibilities everywhere and notice things you can use in the studio that you probably never thought about before!

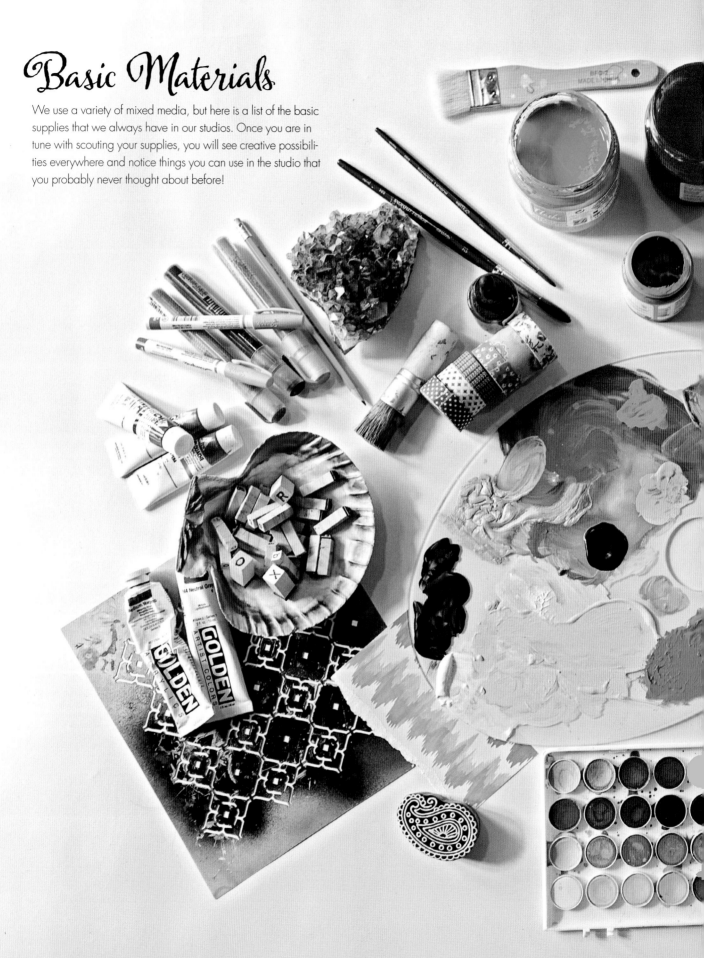

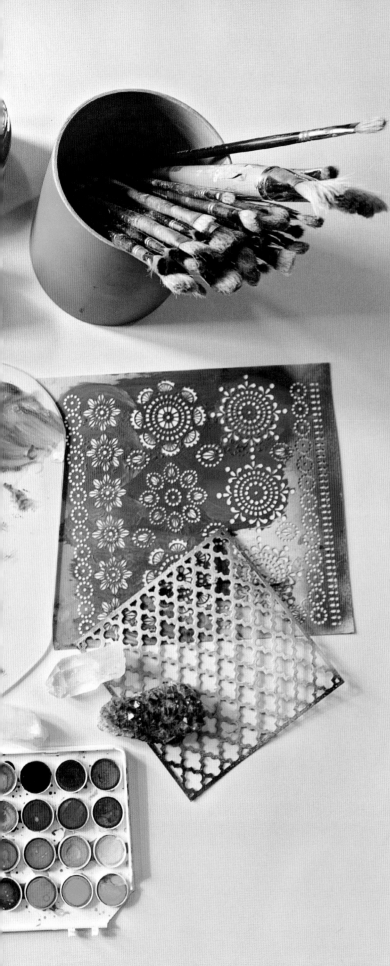

PAINTING SURFACES

We love using wood panels because they are very durable for experimenting. (Cradled wood panels are best because they won't warp.) Canvases are great, too, because they are absorbent and have great texture. We like pre-gessoed canvases, but get a mix to see what *you* like best!

ACRYLIC PAINT

You'll want a variety of acrylic paint, including the primary colors for mixing (red, yellow, blue) as well as Titanium White and black, and then colors you are drawn to. If you are just beginning, a starter set can be really helpful to build your collection of paints.

Our favorite brand is Golden, especially for Titanium White, which we buy in larger tubs for a bigger quantity. Golden can be a bit pricey, so don't worry; any acrylic brand works. We recommend getting some basic colors in the Golden brand (white, carbon black, primary colors) and then grabbing a selection of fun colors that you are drawn to in cheaper brands.

PAINTBRUSHES

It's helpful to have a combination of medium and small brushes with different tips (a brush pack is a good place to start) and a few big ones that feel good to you. In addition to watercolor brushes (sable or natural fibers are best), try to get brushes specifically for acrylic paint.

WATERCOLOR SETS

Start with one or two pan sets containing colors you love.

WATERCOLOR PAPER

We like Arches brand, but any watercolor paper works.

ACRYLIC MEDIUM

Our favorite brand is Golden Gel Medium in medium body. We prefer the semi-gloss finish, but you may like a high-gloss or matte finish. Mod Podge also works really well for collage.

COLLAGE PAPERS

Paper for the collage we'll explore in this book can come from scraps found in recycling, wallpaper, vintage photos, decorative scrapbooking paper or whatever you are drawn to.

SCISSORS

There's nothing like a good pair of sharp scissors.

PAINTING SPACE SETUP

- **Container for water**

 You probably have a large jar or yogurt container on hand; old bowls work well.

- **Palette**

 Disposable palette papers are great for quick-and-easy cleanup—even a stack of paper plates works perfectly. For the long term, we prefer investing in a large piece of glass that you tape to your work surface and scrape clean after use.

- **Paper towels**

 Or a rag like an old T-shirt.

- **Hair dryer**

 Or a heat gun to help speed up the drying process.

- **Water bottle**

 You'll want this for spraying paint and creating washes.

MISCELLANEOUS

In the chapters ahead, we'll show you various ways to experiment with these:

- **Squeegee, old credit card or old hotel keys**

- **Silver or gold leafing kit with adhesive**

- **Acrylic paint markers**

 Any brand will do in the colors you like. We recommend basic colors like black, white and gray, as well as some bright colors that you love.

- **Spray paint**

 A couple cans in colors you like. Metallics such as gold are especially fun to work with.

- **Stencils, lace or doilies**

 Think chevrons, geometrics, mandalas or any pattern you are drawn to. Most craft stores have a huge selection of stencils in a variety of fun shapes.

- **Transfer paper**

- **Scanner or camera**

 You'll want this to capture images of your paintings if you want to share them! We'd love to see what you create based on the projects in this book; use our hashtag on social media: #paintingthesacredwithin.

YOUR COLOR PALETTE
Let's talk a bit about how to choose your color palette.

Mati and I use colors that make us happy and that we feel an intuitive connection to. Most of our work is very bright and colorful, with a heavy focus on turquoise and pink tones, just because these are our favorites. To break out of a color rut, it can be fun to think more in terms of a "color story" in a particular painting. Selecting a palette of three colors that you normally would not choose to combine, like periwinkle, peach and beige, can be an exciting way to move out of your comfort zone and make room for discoveries. Both of us occasionally take time to sit down and think about color schemes that excite us, and then try to focus on just those colors in one painting, which is a bit of a departure but always leads to interesting results.

Color is such a huge part of our work and our lives (living in a colorful home makes us both feel most alive and vibrant), and this energy definitely carries over into our work in the studio. Color has been shown to greatly affect mood, and I feel my own mood shifted by color. That said, I have felt the beginning of a transition in the layering with my paintings. I am bringing more white back into the top layers of my work, thus muting the underlying bright colors, creating a more neutral feeling overall. There is a beautiful, delicate subtlety to the use of white that has been speaking to me, and I'm excited to see where that goes in my current work. So far it is manifesting as white flowers and detailed paisley forms in layers that dominate large areas of the paintings. Color isn't going anywhere in my work, though—far from it—but it is taking the form of a grounding element to the neutral elements of my most recent work.

Throughout the chapters in this book, we'll discuss the following design elements and share how you infuse them in your artwork—line, texture, form, light, scale, pattern, balance, unity, contrast, color, rhythm and variety. Within each of our paintings, each of these design elements is important, and we try to find a good balance. The exciting part for you is that there are so many possibilities within each design element. For instance, with scale, you can choose to go huge or tiny!

—Faith

The Painting Process

CLAIMING SPACE AS YOU BEGIN

Every time we enter the studio, we go through a process of claiming our space to get ready to work. For each of us, this takes different forms; it can be as simple as turning on our favorite music, lighting some sage and getting out the paints. It is a process of letting go of the outside world in order to make space for your complex inner voice to speak loud enough so you can hear her speak clearly! Some days it can be harder than others to settle your mind. Do you already have a way that works for you to enter into that creative head space? Do you have any rituals in place that help you get started? Do you turn on your music, move your body, lay your hands on your canvas or paper, pray? Sometimes we have to journal out all of our feelings first to clear the chatter. Developing gentle rituals that give you access to a sacred space within yourself and your physical world can be powerful tools in your art practice, working as a shortcut to calm the racing mind and functioning as a transition point between studio time and the outside world. One of the best ways that I have found to do this is by setting up a personal altar where I keep bits and pieces of things collected in nature, and a spot to light a candle or incense bought in faraway lands.

Let your mind be still, for the wisdom you seek is like that butterfly over yonder. If you try to catch it with your intellect, it will simply fly away. On the other hand, if you can still your mind, someday when you least expect it, it will land in the palm of your hand.
—**Sydney Banks**

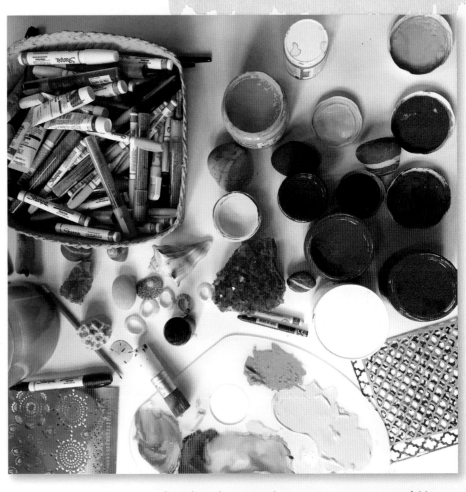

PAINTING WITH RHYTHM AND INTUITION

We'll walk you through our process of painting and our thought process in the choices we make as we approach our art. For example, how to work with each element through varied types of mark making, using a light wash to begin each piece and then bringing in the line of hand-drawn elements, the heaviness of darker opaque colors and the rhythm that layering these varied ways of working creates.

We both work intuitively and find joy in spontaneously reacting to what is happening in the paintings. Even if we come to the blank canvas with an idea for a painting of a flower in a specific color palette, the painting becomes its own creation, unfolding magically and mysteriously in front of our eyes. We hope to capture this sense of play, discovery and engagement with each painting we demo in this book. For if we tried to recreate them, they would certainly come out differently—which gives you permission and encouragement to use these demos merely as starting points and to go on your own adventure!

—Faith

The best advice we would offer to anyone who wants to paint is this: Just show up as often as you can and do the work. Start painting—just begin. You are gorgeous and special; don't waste too much time worrying about what other people think of you! Making your art is what will lead you to your truest self. Don't judge yourself harshly, and have patience with yourself. Doing work with passion is contagious; others will see your spark and be inspired, too!

If you're feeling a bit fragile and in need of encouragement (aren't we all!), write a supportive note to your artist self and put it up in your space. A simple "YOU GOT THIS" helps heaps. Write it on your mirror with lipstick to remind yourself daily!

And when you're feeling stuck . . . know that we are always here to support you. When you're feeling stuck or in need of finding your tribe, head on over to our websites for support! **matirose.com** and **faithevanssills.com**
—Faith & Mati

You Hold the Key
Faith Evans-Sills

Stephanie Perkinson

Our friend Stephanie is a certified holistic health coach. We reached out to her because she is talented at claiming and holding sacred space. We asked her how she would approach creating a personal altar.
—**Faith & Mati**

TALISMANS AND PERSONAL ALTARS

A talisman can be anything. A shell, a book, a crystal, a simple string tied around your wrist. I have been using talismans and altars to reclaim sacred space for over a decade, and for me, talismans feel like hope—a source of power outside of myself, yet connected to my deepest thoughts (the ones that I tend not to share with everyone). Working with talismans and building altars with them can be quiet work, allowing you to tap into a source of magic that is immediately grounding and centering.

These tools can be a touchstone to whatever process you're working on. I like to think that my deepest desires get transferred into these little objects and then transmuted to serve my highest good. Finding your talismans and creating altars is transformative.

Altar making allows us to go deeper within ourselves, to help us really sink our teeth into our personal and spiritual projects. I want to share a story with you. Several years back, I found myself at a beach in a town I longed to move to, back when my family was dreaming about where our next landing would be after the apartment complex we currently resided in. I desperately wanted to live by the sea, so I collected rocks from the shoreline and rose hips from the bushes that grew on the outskirts of the dunes. I intentionally placed the rocks in a space of my home that feng shui says holds the energy of travel and helpful guides. I hoped that the ocean energy of these objects would bring my family to the right place. I strung the rose hips on simple twine and hung them above our bed, not knowing at the time that they are associated with the planet Venus—the element of water—and are used to bring about more love and peace. How appropriate to place in a bedroom that lived in the abundance corner of our home, a section whose guiding element is water! All these tiny synchronicities are not lost on me; this is when the magic begins to reveal itself. You don't always have to understand it all from the get-go.

Sometimes talismans come to us. Sometimes we seek them out. There is no right or wrong way to find your talismans and begin building an altar. It all starts with gentle intention for yourself. Your beloved objects may come from an unlikely source and may not seem flashy or special. Trust that there is a reason this object speaks to you. Spend time with it. Hold it close. Place it with intention. Let altar building support and lead you deeper into your own personal story. Let your talismans connect you to your essence. Let the process of sacred space making allow you to begin once again.

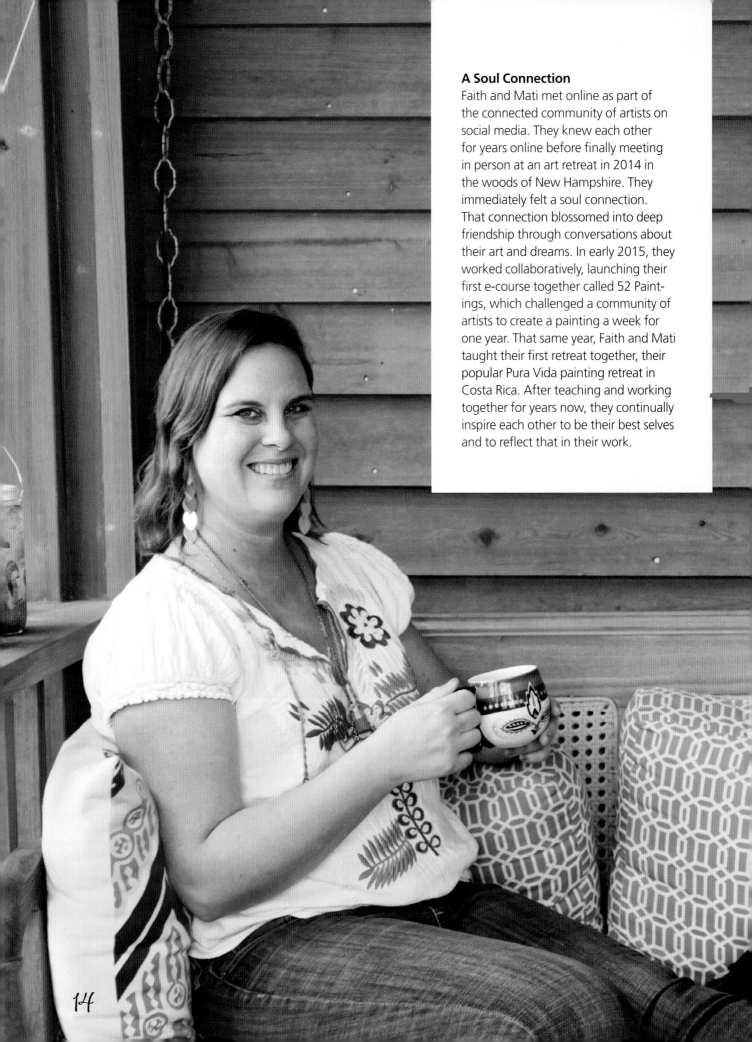

A Soul Connection

Faith and Mati met online as part of the connected community of artists on social media. They knew each other for years online before finally meeting in person at an art retreat in 2014 in the woods of New Hampshire. They immediately felt a soul connection. That connection blossomed into deep friendship through conversations about their art and dreams. In early 2015, they worked collaboratively, launching their first e-course together called 52 Paintings, which challenged a community of artists to create a painting a week for one year. That same year, Faith and Mati taught their first retreat together, their popular Pura Vida painting retreat in Costa Rica. After teaching and working together for years now, they continually inspire each other to be their best selves and to reflect that in their work.

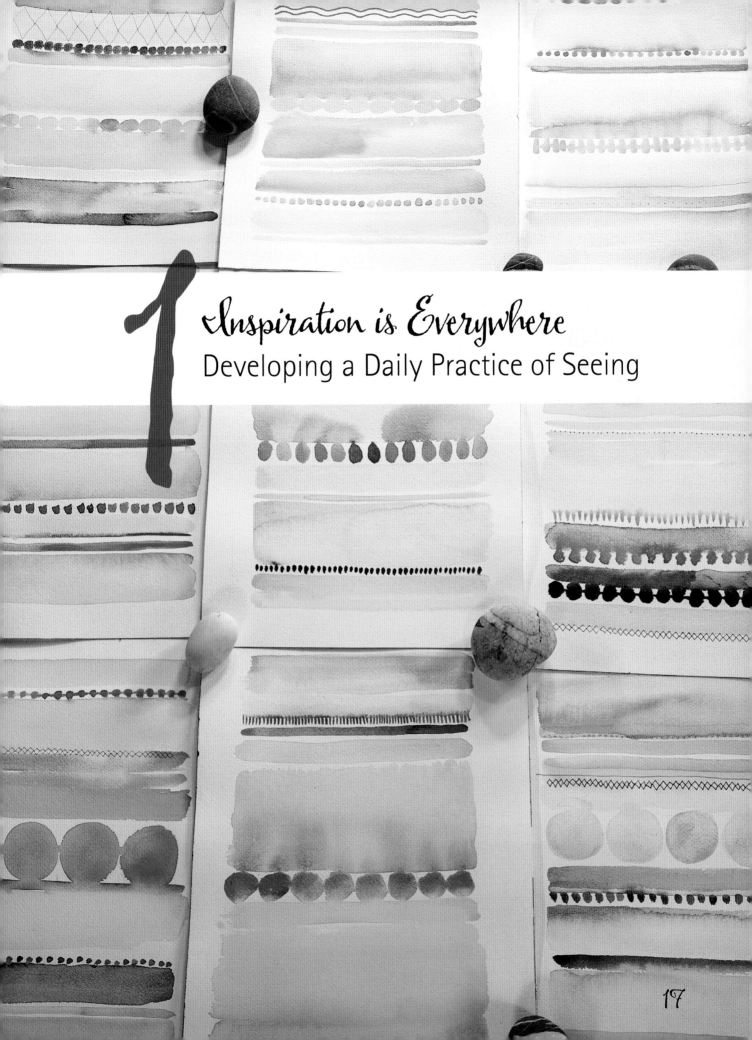

1

Inspiration is Everywhere
Developing a Daily Practice of Seeing

> I have just three things to teach: simplicity, patience, compassion. These three are your greatest treasures.
> —**Lao Tzu**

My painting process is very organic; it can be as simple as painting with a stick or as complex as creating my own language through repeating shapes and marks that hold deep meaning for me. One of the foundations of my painting practice is drawing inspiration constantly from my environment, from what I collect, my travels and my home by the sea. Sensing, feeling and exploring my world, I have developed tools to try to always keep myself open to inspiration. A big one is keeping a sketchbook and pen with me at all times; if visual inspiration strikes, I record it. I find that the more open I am, the more I see things that inspire me. For as long as I can remember, I have made collections of things that I found on walks in nature. Shells, feathers, leaves, pebbles and sticks all made their way home with me to become parts of fairy houses as a child, and now such items sit scattered on shelves and tables throughout my home, bringing the outdoors in and serving as reminders of the spark of aliveness I feel outdoors.

Before I even start painting, though, there is a lot of work that I call "silent work," the part where I am absorbing information, gathering inspiration and settling myself down to work. Each

painting begins as an idea in my head, then goes on a journey through my experience out onto the canvas or paper. The only way I can describe my painting mode is as a kind of meditation in which I have access—however briefly—to the deepest part of myself.

My most helpful tricks for staying constantly open to inspiration are not necessarily ones I use while painting; rather, they are things I use all the time to keep myself ready and primed with creative energy so when I have time, I can jump into my work. I am always on the lookout for inspiration when it comes!

One of these tricks to keep myself on my toes looking for inspiration is to make sure I always have a camera with me. I often use the camera in my phone to snap shots of my everyday life, simple beauty I encounter in the natural world. Capturing these things helps me to stop and step back, seeing the magical within the everyday.

This type of inspiration seeking is one of our favorite things to do and can become a goal in and of itself. A fun inspiration-seeking exercise to keep yourself fired up with inspiration is color treasure hunting. Challenge yourself each week to do a color treasure hunt for a specific color and see what you find (you can work your way through the rainbow, starting with red). Walk around the block or anywhere exciting and take at least ten photos of things in your chosen color with your camera or phone. If you have neither, draw them. Pick up leaves, flowers and debris on your walk for future inspiration. Depending on where you live, this may be an extra adventure or be an inside job in your house!

All of these tricks and tips to keep yourself on your inspiration-gathering toes are really about taking your time to slow down and dive deep into your painting practice. Think about your painting work as a "practice" requiring daily or weekly attention. Anything that you dedicate mindfulness to grows and flourishes.

One of the ways we stay fired up and paint daily is to make it easy for ourselves. Choose accessible materials, like watercolor, to warm up. We've started calling this way of working our Watercolor Warm-up, and I'll share it with you in the demo to follow.

—Faith

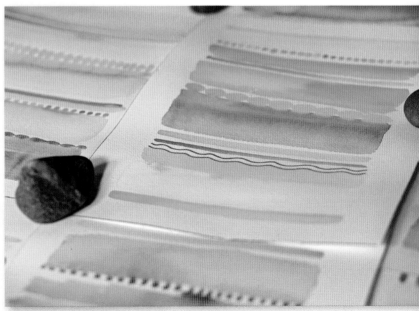

Color Treasure Hunting

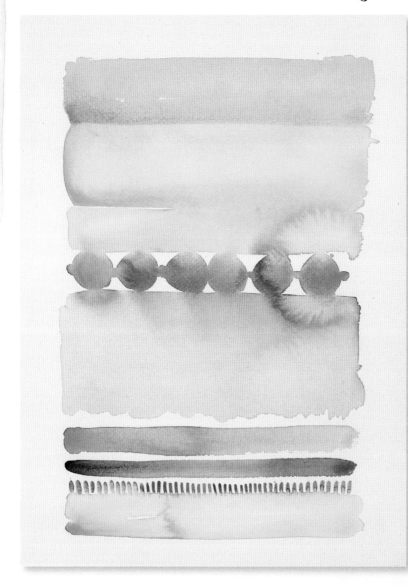

WHAT YOU'LL NEED

rag or towel to blot your brush

water containter/water

watercolor brushes (sable are best)

watercolor pad, cold-pressed if possible

watercolor set with a variety of colors you love

This is about taking immediate inspiration from your surroundings, developing a color-and-shape shorthand gathered from earlier inspiration gathering. In this demo, I am drawing inspiration from a walk on the beach near my home, as well as some of my collected rocks for shape inspiration. I love how they each become a unique expression of my experience of the natural world.

Start by sitting down with your materials and looking around, focusing your attention on your immediate environment or on a recent experience in which your surroundings inspired you.

Simplify your visual experience of the place; look at colors and lines. This imagery will become the stripes or areas of color that, when combined on your paper, will add up to a whole that speaks to the moment you are thinking of.

Quick Tip

I keep all of my smaller brushes in this roll that protects them and is easy for travel; for watercolor, I like to use a few different sizes of sable brushes. All of the supplies for this lesson can easily become a travel painting kit that you take with you everywhere, capturing the feeling of locations you can visit again and again for inspiration in your paintings.

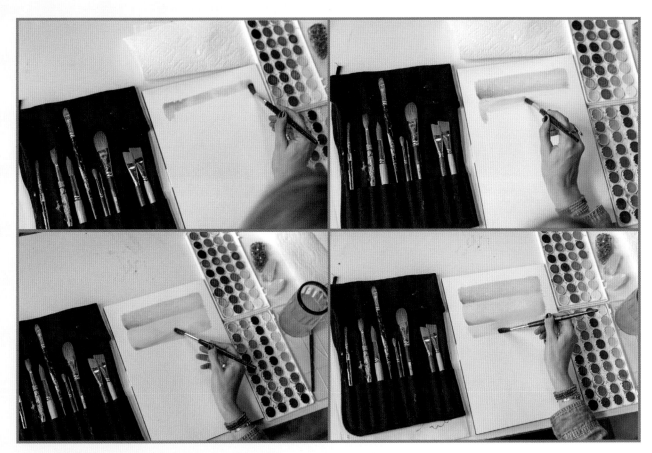

1 Think about your inspiration, the colors that you saw around you, and make each color into a stripe in your painting. Have fun as you paint, making it an exercise for yourself to not think at all about making it perfect or about the final outcome. Simply enjoy the way the colors bleed into each other as you work. The happy accidents that result from the combination of paint and water in this way of working are my favorite part.

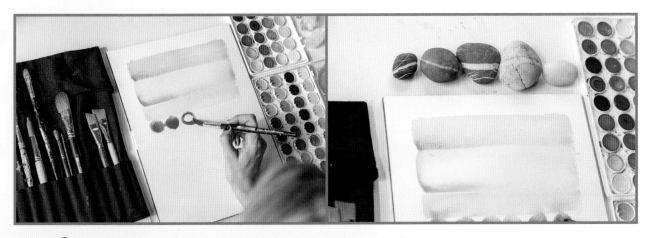

2 Alternate between painting stripes or blocks of color with more detailed circles and shapes. If you're like me, a line of brown circles could represent a lineup of rocks you've collected. Look to what you love to collect; what forms and shapes do you see?

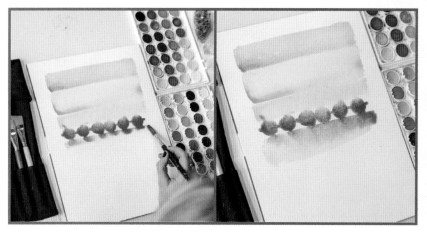
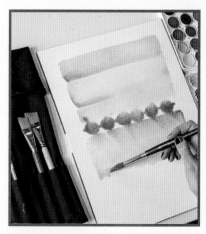

3 Immediately after you've painted a row of circles or shapes and they are still wet, go back with a very wet brush and lightly touch each shape with the watery tip of your brush. This activates the color pigment in the shapes and will cause them to run and bleed together in interesting and unexpected ways.

4 For a cohesive feeling in your painting, repeat some of the colors you have already used in your piece.

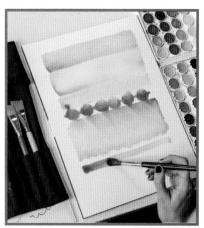
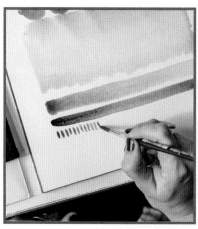
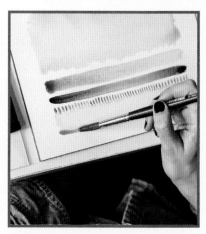

5 Adding a couple of lines of darker color grounds the piece and adds pleasing contrast to the lighter colors.

6 Experiment with adding a variety of marks. The fine detailing of these marks presents a contrast to the flowing watery feeling of the watercolor blocks.

7 Go back in with your very wet brush and barely touch the painted marks to allow the pigment to flow a bit.

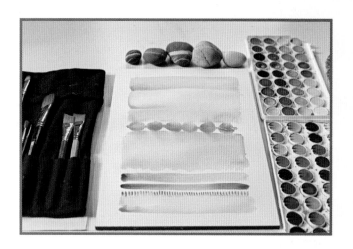

8 As you finish up, remember to look at the whole piece and think of what colors you want to accentuate to keep the viewer's eye moving all around the painting. Adding this pop of turquoise reminds me of water and sky, reflecting the ocean theme of this painting and mirroring the turquoise at the top of the piece.

Andrea Scher

COLOR COLLECTING

Have you noticed the color on the sidewalk lately? Perhaps it's a sea of leaves. Or a confetti of plum blossoms. If you are in a more urban setting, it could be some colorful graffiti. If you are in snow, maybe it is a brightly colored pair of boots.

Your mission today is to notice the color at your feet.

Something to try:

1. Set the camera on the ground.

2. Click the shutter.

3. See what you get! (That's how I got the shot here.)

Our photographer artist friend Andrea is an expert at color collecting. We asked her how she approaches her color treasure seeking so consistently, and she offered the following exercise from one of her classes.

—**Faith & Mati**

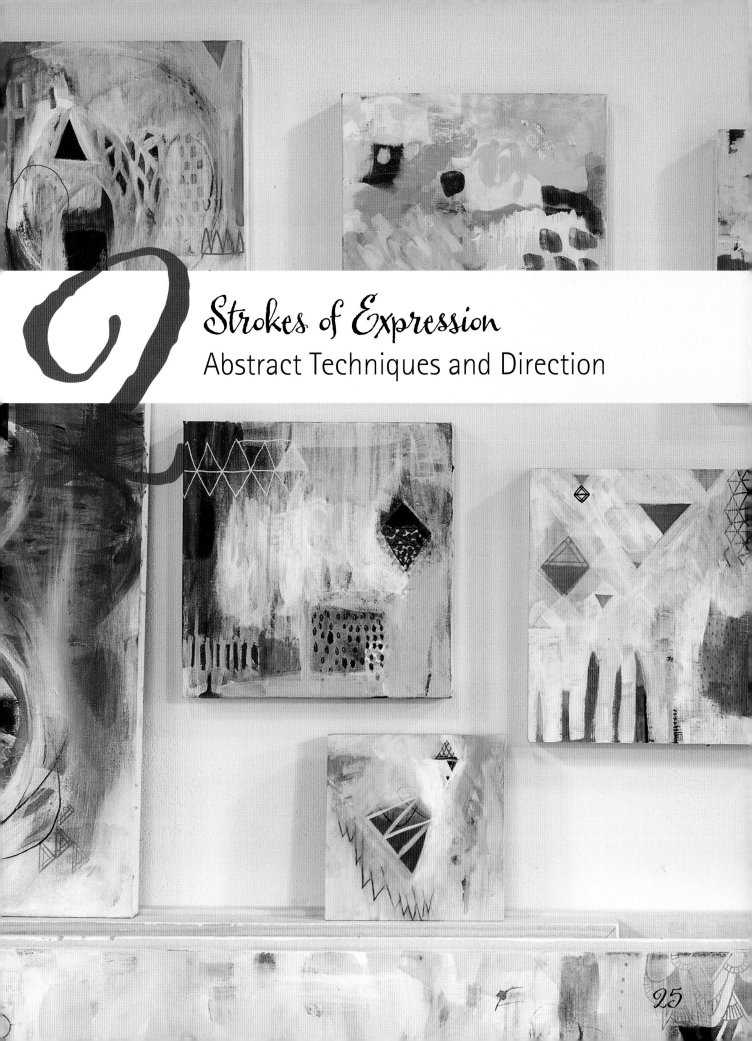

Strokes of Expression
Abstract Techniques and Direction

25

> The freer the soul, the more abstract painting becomes.
> **—Marc Chagall**

One of the things I love best about painting is the feeling of the smushy paint under my brush—scooping up colorful dollops and spreading them across the canvas with abandon. Abstract painting allows you to explore the feeling and viscosity of the paint and make bold, wild moves expressed from deep within.

The process of mixing yummy paint, spilling, finger painting, letting it drip… it's all so visceral and just makes you want to eat it up! It must appear sometimes that I am literally eating paint, as I always end a painting session with bits in my hair and inevitably on my face and all over my hands.

Abstract painting has the ability to show the unfettered history within mark making. It captures time like no other, like a dance on the canvas that can never be repeated in the exact sequence again. Showing emotion in fast swipes and delicate swoops.

Hence, it is also very physical and can be full of expression. With abstraction we have the opportunity to begin very loose and create chaos. Then we can reign it in and make concrete choices on how to calm it down. Our canvas mirrors how we can do this in life, too. Create disorder and excitement, then work through the muck to get to the beautiful, serene bits, or keep the wild, colorful swoops!

We wanted to help you get to this place of play with abstraction by providing prompts for you to keep it fresh and mix it up.
 —Mati

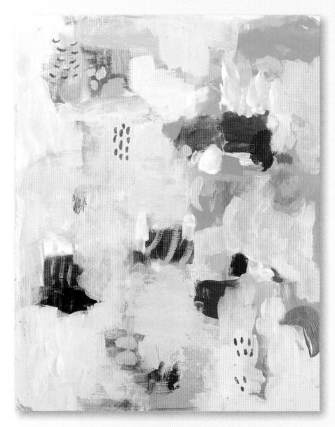

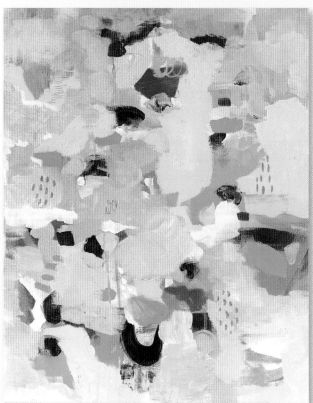

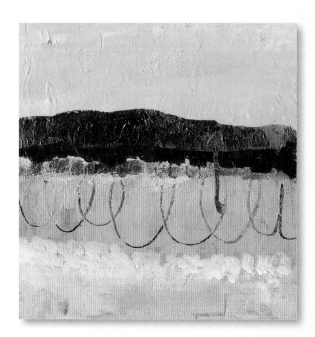

Summer Sorbet Series
Mati Rose McDonough

energize piece	REPEAT	cover part
SPILL!	finger paint	QUIET piece down
WATER BOTTLE	close eyes	switch brushes
BRAYER	FAST!	Non-Dominant Hand
Slow	ETCH	squeegee
BE BOLD	Add White	vary marks
use unconventional tool-fork, cap, lego, etc.	use small brush	Add BLACK ****
use BIG brush	be gentle	Get * geometric ◇◇◇◇

Copy this page and cut out the prompts to use in the demonstration to follow.

Using Prompts for Abstract Mark Making

WHAT YOU'LL NEED

acrylic paints: black, white and a variety of colors you enjoy

canvas

copy of mark-making prompt cards (from previous page)

paintbrushes, one large and one small

palette

squeegee

water container/water

water spray bottle

utensil for etching

The goal of this abstract painting demo is to loosen up, experiment, play and let go. Using these prompts is a fun way to explore different mark-making techniques. It's a good way to see what works for you and to discover your own unique marks. In addition, this is a great way to get out of your head. Because you'll be picking prompts from a bowl, you'll be letting go of some control of the outcome, thereby silencing your mind a bit. Be loose and free by picking colors quickly and working from prompt to prompt. You can come back to this exercise whenever you are feeling stuck.

We will work with one canvas, building up layers. In the next demo, we will use the same canvas, adding metallic gold leaf to it.

To get started, prepare your prompt cards. Make a photocopy of the cards on the previous page, cut them up and put them in a bowl. Alternatively, you may wish to write your own. Either way, keep in mind, they will get paint on them! This demo will go through eight of the prompts. For the remaining cards, don't overthink what they mean; do what instinctively comes to you!

Start with a palette of your choice. Choose a couple colors to begin and add others as you are moved. Begin painting on your canvas with your smaller brush. I like to hang canvases on the wall to free up my entire body to move.

Begin drawing prompts from the bowl. Refer to the following photos that correspond to your prompt. After giving that technique a try, draw a new prompt and proceed with it. Continue drawing new prompts and experimenting for as long as you like or until you are out of prompts!

Squeegee
Use a simple credit card as your tool. Cover the edge of your squeegee tool with paint and wipe it on the canvas.

Spill
Spill paint onto your canvas. I like to run the tube along the top and let it drip all the way down the painting.

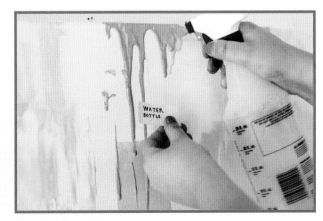

Water Bottle
Use a water bottle to spray your painting.

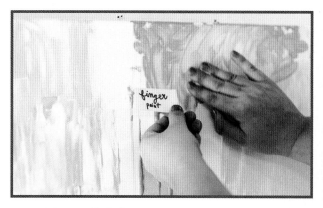

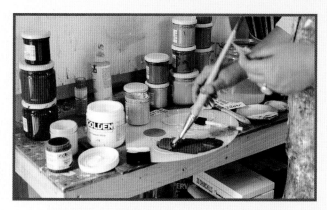

Finger Paint
Go on! Get messy just like you're back in kindergarten!

Mix New Colors
Continue to mix up exciting new colors that work well with your palette.

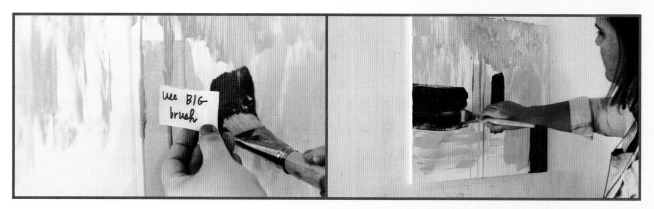

Use a Big Brush
Use a big ol' brush! Think about varying the direction of your marks from vertical to horizontal.

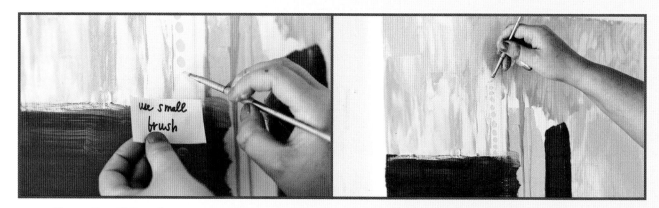

Use a Small Brush
Use a small brush and make small brushstrokes. Think about varying the size and shapes of your mark making. Embrace each prompt fully!

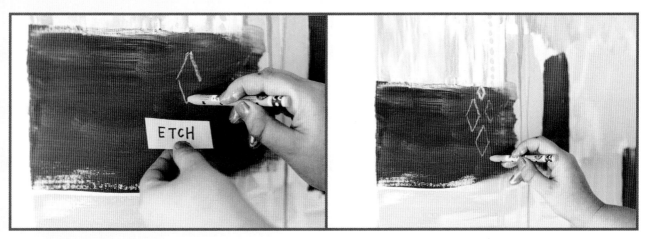

Etch

Take a writing utensil onto wet paint and draw. I'm using a pastel crayon here. It helps to repeat your etching in a pattern to build cohesion and as a way of weaving the colors with marks.

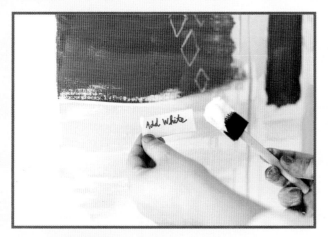

Add White

Straight-out-of-the-tube Titanium White can be your power move to brighten your work and simultaneously calm it down.

Working in the flow is sometimes beautifully chaotic.

Adding Metallic Leaf to Your Work

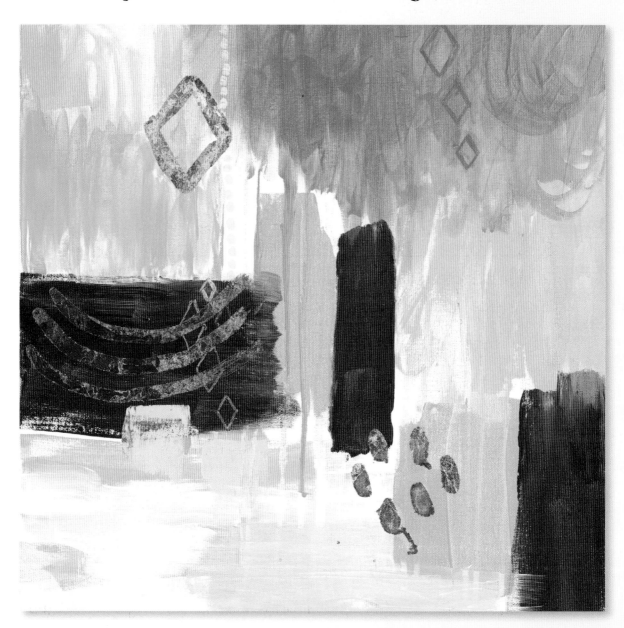

WHAT YOU'LL NEED

- gold or silver leaf
- hair dryer or heat gun (optional)
- leafing adhesive (such as Mona Lisa products by Speedball)
- pencil
- previously prepared painting

Metallic leaf instantly elevates and transforms a painting—not only in terms of the glimmering result, but also the process, from taking the fragile, shimmering sheets of silver or gold leaf to the way it breaks into tiny flecks. Just gorgeous!

Quick Tip

I've found that if you have a lot of gel medium coating your surface, the metallic leaf may also stick to that. So it may be possible to use gel medium as an adhesive, but I haven't tried it specifically.

1 Selecting a somewhat solid field of color within your painting, use a pencil to sketch motifs, lines or other imagery you'd like to see in foil. Apply leafing adhesive to the sketched areas. Create a pattern if you'd like with multiple lines.

2 Let the adhesive dry for about an hour. (You can leave it overnight and it will still be usable the next day.) It will be tacky but not wet. To speed up the process, you can use a hair dryer or heat gun.

Carefully take a single sheet of gold or silver leaf out of its package.

3 Place the sheet of gold or silver leaf over the adhesive area of the canvas and press with your fingers.

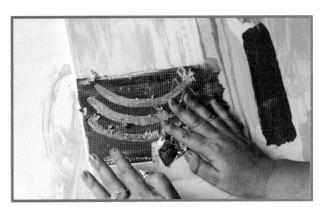

4 Press down with your fingers to make the metallic leaf stick to the adhesive. Lightly brush away the excess. Use additional sheets of leaf if needed to cover the area, and continue brushing away the excess.

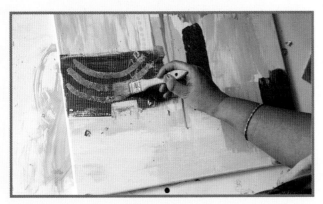

5 Using a stiff dry paintbrush or your fingers, brush the excess metallic leaf from the canvas.

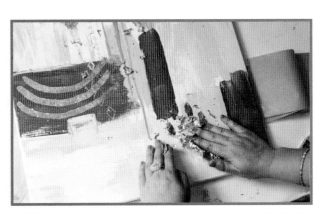

6 Create multiple areas of interest with the metallic leaf. You can press small bits or larger bits onto the adhesive and layer it because it will all stick and look good.

33

After you've created many marks, gone through multiple card prompts and have built up some painterly chaos, you'll want to bring your critical eye back to your painting and consider the following questions:

- What do you want to save?

- What do you want to cover?

- Repeat what you love!

- Slow down and listen to the painting; be a little more deliberate.

- Remember, harder lines and compositional elements organize a painting; contrasting colors help keep it dynamic.

Also, keep in mind these cohesion goals:

- Ask yourself: *Is my eye moving around the canvas or does it get stuck? How do I make things cohesive?*

- You know you're finished when your eyes move fluidly around the canvas without a nagging . . . *I want to do more to this area.* It flows and feels complete. This takes a lot of trial and error, but try feeling into this completeness.

- Step back and admire the painting and really see what's happening. Put it on a blank wall and look at it.

- Turn it upside down to see it differently!

- If you're feeling tripped up, alter your perspective and think about the goal being to make an ugly painting, because that's where you LEARN the most! Be DARING!

- Repeat all of the above steps if you feel like you want to keep playing, pushing and transforming. Sometimes paintings take a looooong time to complete. Sometimes they are born in fifteen minutes. Trust this!

True Spirit
Faith Evans-Sills

34

To Inspire You

JANELLE GURCHINOFF AND LAURA HORN

Janelle and Laura are students from our year-long e-course. We chose to include their work because they each exhibit great exploratory mark making, color choices and rich layering.

—**Faith & Mati**

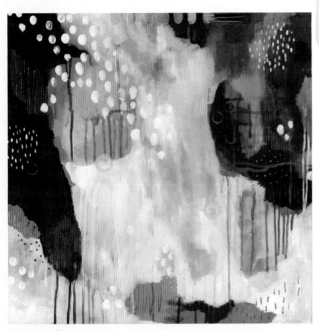

Jungle Life
Laura Horn

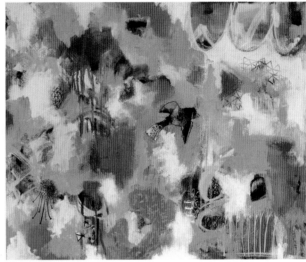

Remembering How to Fly
Janelle Gurchinoff

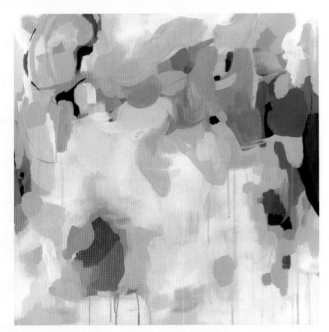

Time Stood Still
Laura Horn

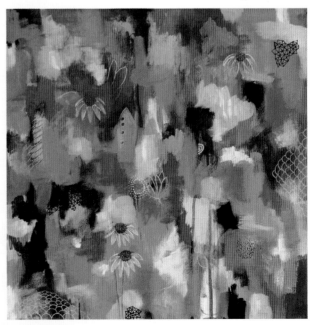

Healing Grows
Janelle Gurchinoff

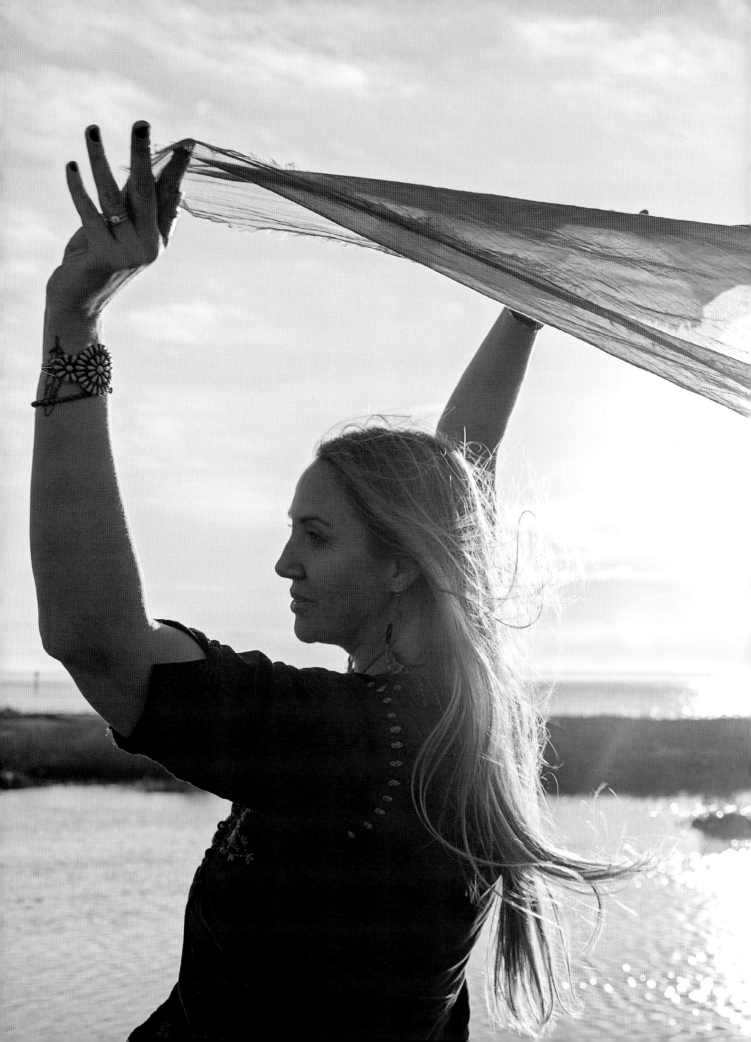

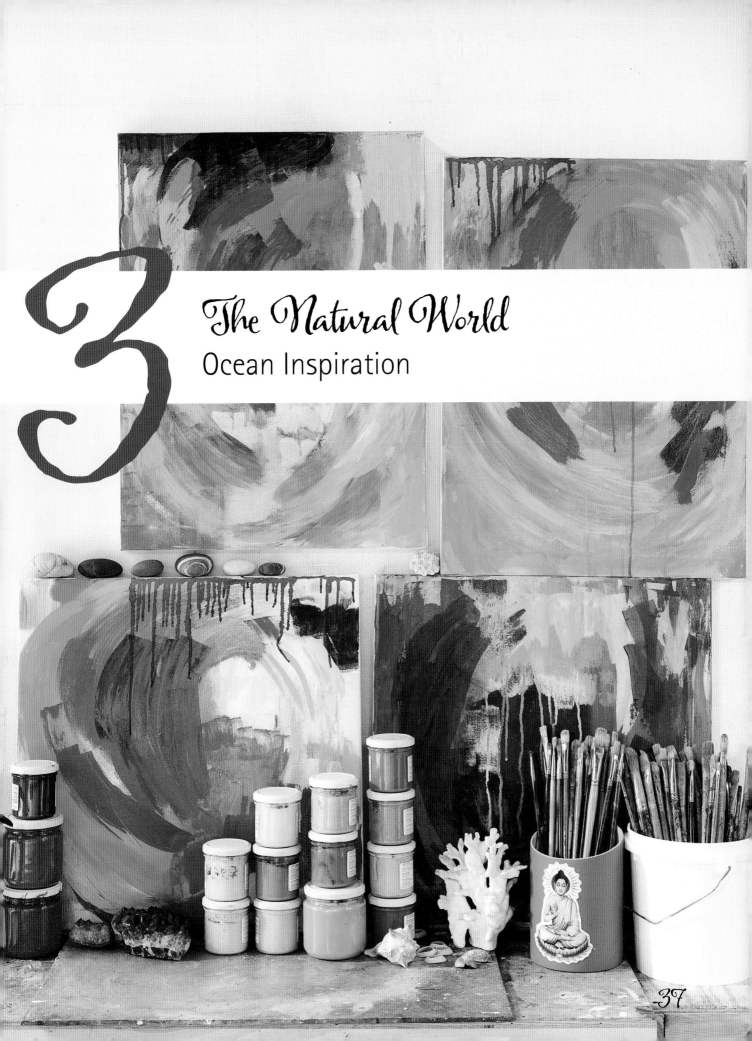

3 The Natural World
Ocean Inspiration

Forget not that the earth delights
to feel your bare feet and the
winds long to play with your hair.
—Khalil Gibran

I believe that we are all innately spiritually connected to the earth, that internally we all feel a call to experience nature with each of our senses. Most of us feel happiest after a day spent entirely outdoors; that windblown feeling of a day spent at the beach reminds us how good the elements are for us and how much our souls delight in playing with them. It can be an exciting exercise to try to capture some of this delight in our paintings, as there is so much inspiration to be found in the energy we experience in nature. Taking color, shape and movement from nature can be a strong way to connect with your environment. Mixing washes, pouring and painting flat are all exercises in capturing this movement in your paintings.

—Faith

Sea Series
Mati Rose McDonough

Ocean-Inspired Paintings

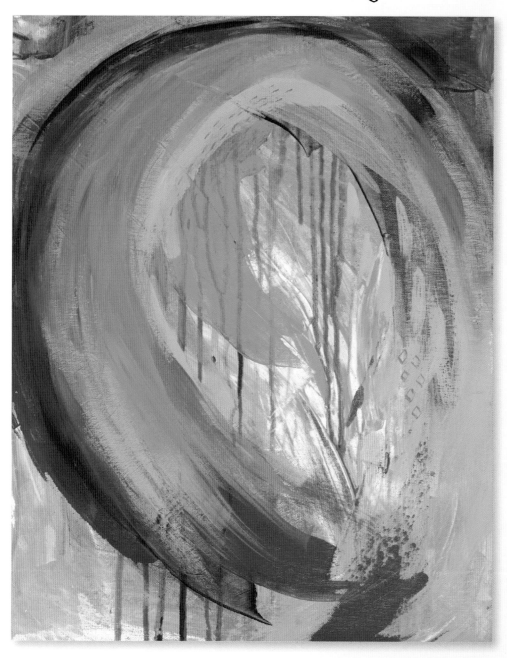

WHAT YOU'LL NEED

acrylic paint, colors you like

canvas

paintbrushes, various sizes

palette

squeegees

water spray bottle

When creating an ocean painting, I'm often trying to mimic the push and pull of the tides and the beauty and power of crashing waves. I grew up in Maine, and the ocean has always left me feeling grounded—salt air, sand beneath my feet and the sound of the rhythmic waves. Are you drawn to the ocean? Follow along, and together we'll try to capture the essence of that connectedness.

Inspired by the movement in the ocean, I'm using squeegees as my primary painting tools. The squeegees create a delicious texture and movement when you run paint across the canvas with them.

1 Gather some squeegees in the form of sample credit cards or expired gift cards. Pour some of your favorite acrylic colors onto a disposable palette. Consider using analogous colors (hues that are neighbors on the color wheel) in the shades of the ocean. Begin by dipping a squeegee into the paint. It's OK to pick up more than one color at a time.

2 Give yourself ample space to create. (Consider working on the ground.) Enjoy the physical process and allow for messes by placing paper or a drop cloth on your floor. Spread your first squeegee marks on the canvas.

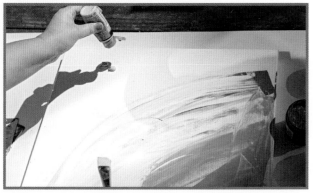

3 In addition to working from the palette, you can drip paint directly onto the canvas. Experiment with a variety of bodies, from fluid craft paint to heavy-bodied paint.

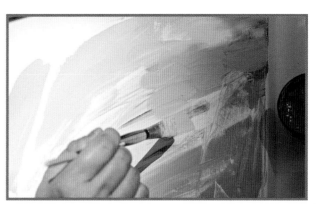

4 Squeegee the dripped paint across the canvas. Add some layers with your brush to build variety. You might consider choosing a golden hue to represent the sand at the ocean.

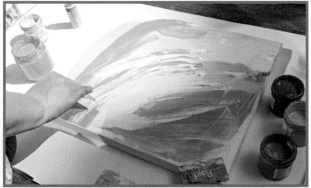

5 Return to using the squeegee, this time with a turquoise shade to build depth in the feeling of the water. Run the squeegee across the canvas multiple times with the color to evoke the movement of a wave.

6 Continue pouring various colors onto the canvas for layering effects. Reapply the same colors you've already used to create cohesion. Step back and consider what the painting needs. Perhaps try dripping paint directly from the bottle onto the top of the painting.

7 Spray water with a water bottle onto the paint, and tilt your canvas to create beautiful drips and runs down the canvas. Using your squeegee, collect and spread the excess paint across the top of the canvas.

8 Return to using a brush, and think about the arching movement of a wave about to break. Continue layering with the brush until you get the opacity you desire.

9 Go back in with a squeegee and create the circular wave motion you envisioned.

10 Build new layers, repeating colors you've already used.

11 Blend the wet paint colors together with the squeegee. Speed up your movements of the squeegee application to emulate the speed of the wave and to capture the fluidity of the ocean.

12 You can focus in with the squeegee and create wisps of the wave by using the paint already on the canvas and making fast little swipes at the end of the curvature.

13 Bring some of the background color—in this case turquoise—to the forefront to make the painting feel more dynamic.

14 Let the paint layers be really thick and juicy.

15 The wave is now coming powerfully into focus.

This is an example of an illustrative interpretation of the sea.

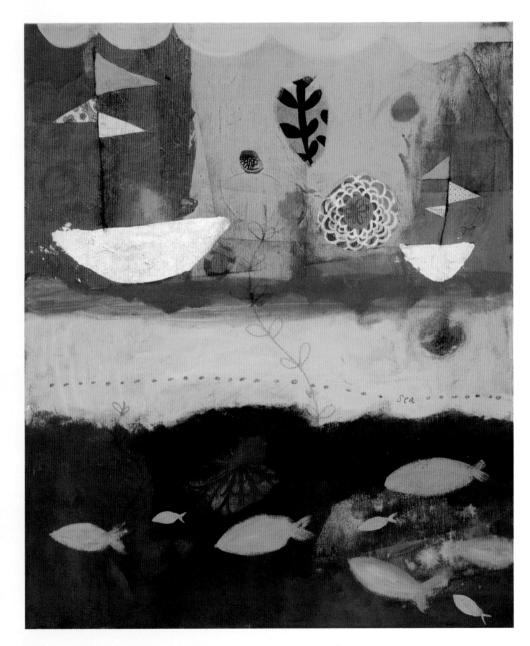

Underwater Treasures
Mati Rose McDonough

43

Creating a Poured Wash of Color

WHAT YOU'LL NEED

acrylic paint, one bright color you love

bowl or large jar

canvas, stretched

paintbrush, large

water

Here is a simple technique you can use when facing a blank canvas. I love the organic feel of the moving water. The paint dries into forms that capture the movement of the watery wash, becoming a dynamic first layer for your painting, full of natural beauty and energy.

Having just spent the week in Costa Rica, I'm inspired by the surfers there and the giant waves they rode.

1 Using a large brush, mix water and a large squeeze of acrylic paint together, adding more paint if needed to create a saturated wash of color. You will know it is ready to pour when you can't see the bottom of the bowl through the wash.

2 Lay your canvas, or a few canvases, side by side flat on the floor or ground. Slowly begin pouring your wash over one of them. Continue pouring until each of your canvases has some of the poured wash covering it.

3 Before the wash dries, lift the canvas to create an angle and get the wash flowing. Move it around, watch the water flow in drips, pick one canvas up and hold it over another, allowing the wash to drip down its sides onto the lower canvas.

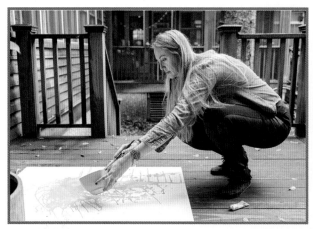

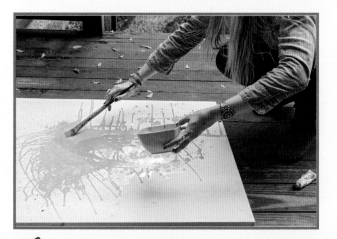

4 Pour out the rest of your wash. Usually there is some saturated pigment at the bottom of the bowl that brings a darker richness of color when you finish pouring every last bit out.

5 Spread the wash around with your brush, crushing and spreading any lumps of pigment, allowing the wash to cover a good portion of the canvas.

Once you are happy with the organic drips and forms that the wash has taken, leave your canvases to dry flat.

To Inspire You

SUZIE CUMMING AND ANNAMIEKA HOPPS DAVIDSON

Suzie and Annamieka were students in our e-course.

—Faith & Mati

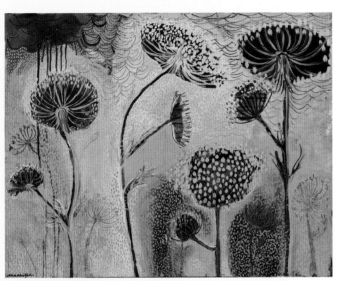

Blossoms in the Rain
Annamieka Hopps Davidson
My home in the Pacific Northwest is nestled into the temperate rainforest, between the mountains and the sea, and I surf the cold waters off the Oregon coast. Rich layers in my paintings reflect a lifetime of exploring this lush environment.

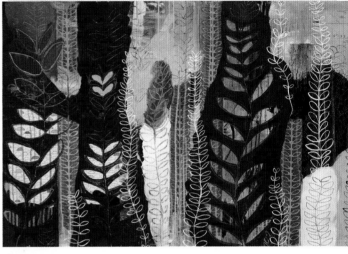

Weave Me Into the Sea
Annamieka Hopps Davidson
The ocean is my spirit place. I experience joy, a state of flow and a sense of collaboration with a much greater energy body while I'm in the ocean. This experience of awe is paralleled in my painting practice.

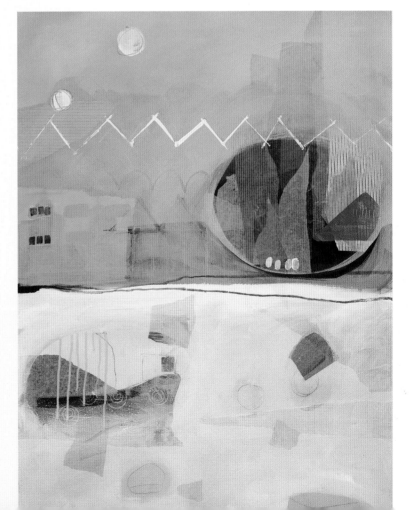

Pink Flags
Suzie Cumming
One of my great inspirations is the sea and coastal landscape. Most years we spend time on the beautiful West Coast in the UK. The natural beauty here is stunning, and I find myself mesmerized by the ocean and its many colors and moods. It could be rolling waves, crashing waves or a calm still with a boat bobbing around and the bluest of skies. Whatever its mood I'm inspired to record it in some way.

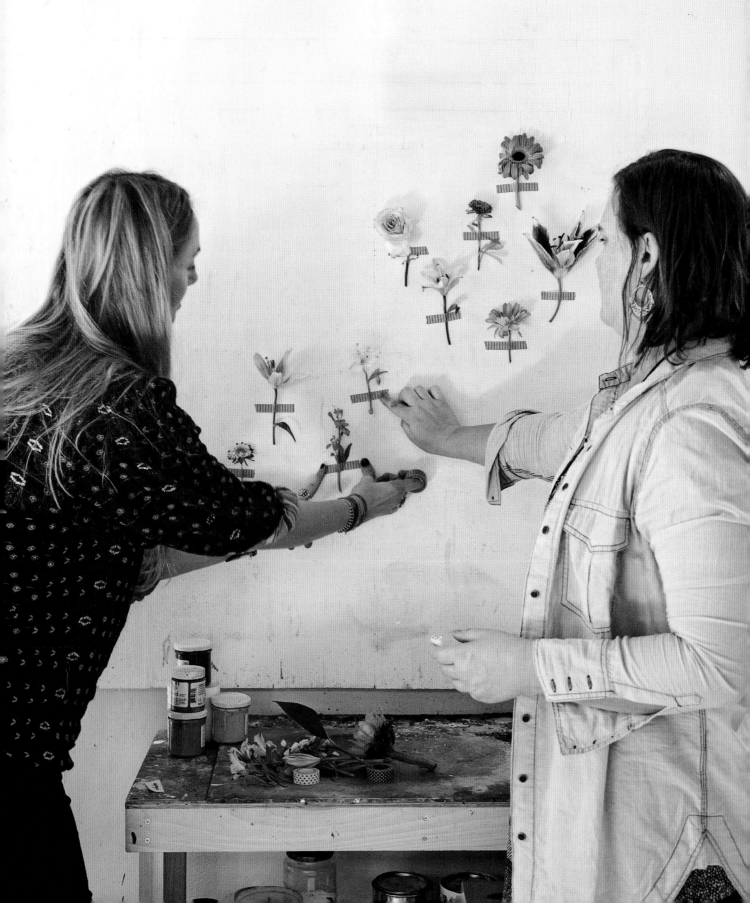

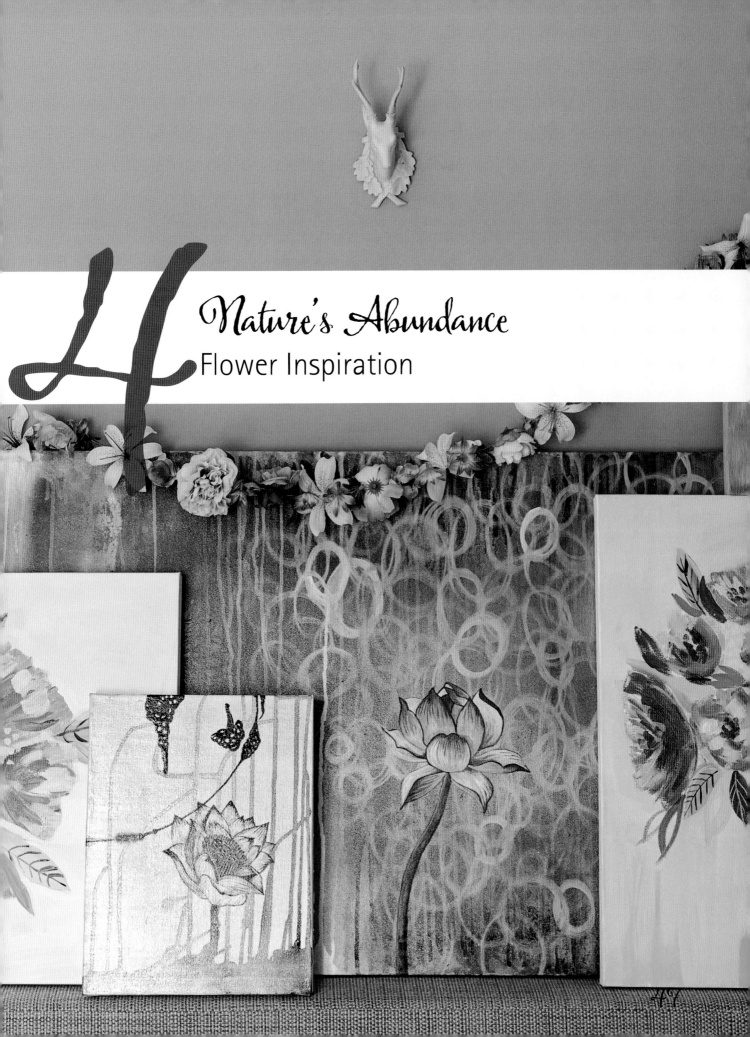

4

Nature's Abundance
Flower Inspiration

Whenever I'm feeling blue, I walk around the block and admire the flowers growing abundantly and year-round near my art studio in Berkeley. Cherry blossoms, magnolias and wild poppies covering the hills all have their season.

Some of my favorite flowers to paint are blooms of ranunculuses and peonies for their delicious colors and round, sumptuous petals. For this demo, camellias were in full bloom in Charleston. They abundantly covered the ground and were therefore the perfect choice.

Whether flowers are found wild or at the market, bring fresh flowers inside to lift your spirits and be inspired. Their colors are naturally inspiring, but also their scent is soul shifting, and the way they grow is a natural offering to behold. Since their lives are fleeting, it makes sense that as artists we want to immortalize them. Much of art is about capturing the impermanent and creating an interpreted permanence that carries on beyond us. Case in point, I only had a day to paint these camellias; when I returned the next day, they had all turned brown and had a beautiful decay.

> # I must have flowers, always, and always.
> **—Claude Monet**

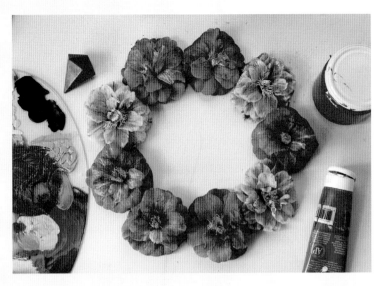

It is fun to play with flowers and create a still life to paint from. Inspired by mandalas, I created a circle of camellias and basked in their hot pinkness.

If you don't have access to actual flowers, design magazines often feature lush bouquets. I frequently take photos of flowers and print them out for personalized inspiration.

Painting flowers can be interpreted in your own unique way with your distinct style. Don't feel like they have to be realistic. You can add elements from your imagination and wild colors. Use your flowers as the beginning of inspiration and grow from there! Embrace your unique marks and flower power!
　—Mati

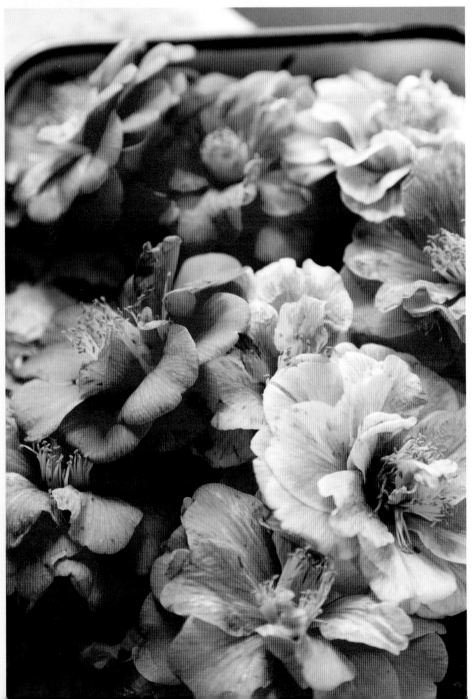

Painting Flowers

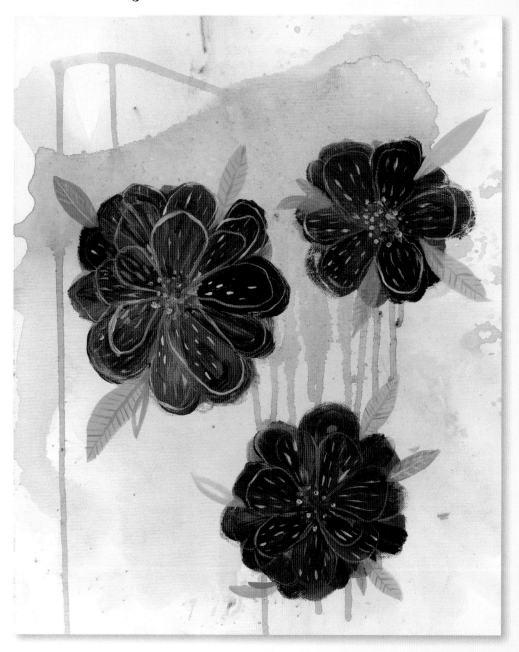

WHAT YOU'LL NEED

acrylic paint, colors to match your flowers

canvas, prepared with poured wash (chapter 3)

fresh flowers or photo of flowers

paintbrushes, a variety

palette

water

In this demo, we'll create a lush flower painting. It's especially lovely to work from live flowers and capture their ephemeral beauty, slowing down and paying attention to the nuances of color and form, while allowing what goes onto the canvas to become a unique interpretation of your own.

We will be playing with shading, dimension and detail to create these gorgeous blooms.

1. Set out a canvas you have previously prepared with a wash (see Creating a Poured Wash of Color, chapter 3). Put out a variety of paints in the shade of your flowers. In my case, I'm using shades of pinks for the camellias. I love Golden Titanium White to mix my colors with. I'm opting for a bubble gum pink to begin.

2. Start by eyeballing the shape of the petal and begin putting paint to the canvas. Create the bloom by painting each of the petals.

3. Fill in the entire bloom by painting all of the petals in this base color. Determine the placement for the second bloom and begin the same way.

4. Continue filling in the base of the second bloom. Think about the composition that works best for you—a triad works well visually because it keeps your eyes moving around the canvas.

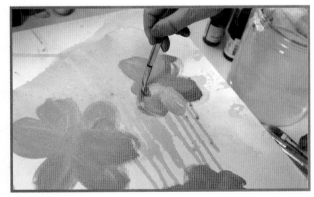

5. On your palette, mix up an even lighter shade of the petal color for layering—in my case a ballet pink. Layer the lighter color over the petals for increased depth in the petal structure.

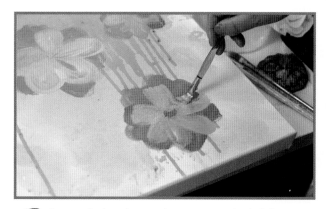

6 Repeat the layering—going even one shade lighter — over all the blooms.

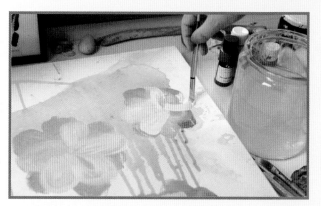

7 For variation and interest, create new petals as well, with the lighter color.

8 Mix a more saturated shade on your palette.

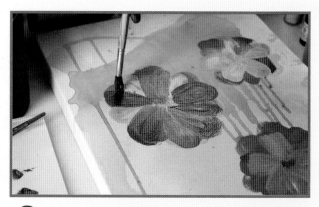

9 For increased dimension, continue layering this deeper shade on top of the petals.

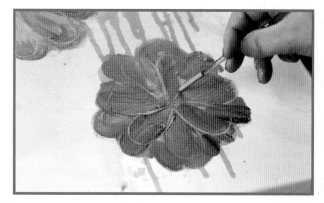

10 Turn your paintbrush over to use it as an etching tool. To translate the delicacy of the flower, etch in the edges of the petals. Repeat this on all the flowers

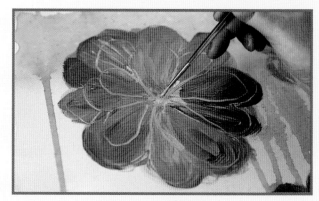

11 With a small brush and a golden orange color, paint the stamen and the center of the flower.

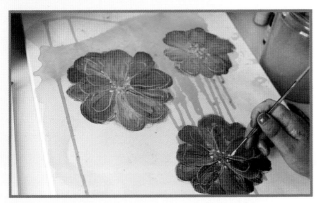

12 Create additional depth in the centers of the flowers with a variation of the last color, again using the small brush. Here I am using a lighter yellow. Repeat this second color on all of the flowers.

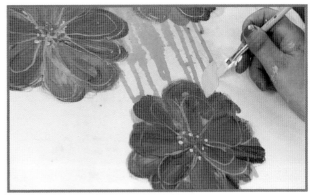

13 For increased visual interest, add leaves. The camellias I have are without their leaves, but for more design and color, I'm making the choice to create leaves from my imagination. Starting with a light green color, use a small flat brush and create a leaf shape. Fill in the leaf so it reads as opaque.

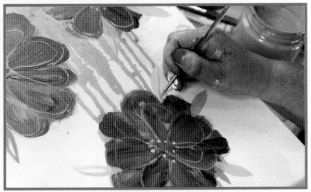

14 Using a darker green, add additional leaf colors to enliven the piece even more. Create a variety of sizes, and be mindful of the design of the leaves to balance the painting. Create a few leaf veins with a small brush line.

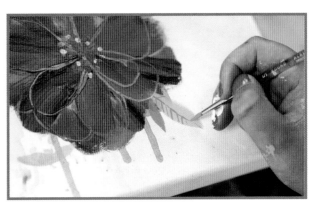

15 Move around the leaves, adding veins to all of them, and add smaller leaves with this brush, too. Using the same small brush, create varying patterns for the leaf veins (such as a feather).

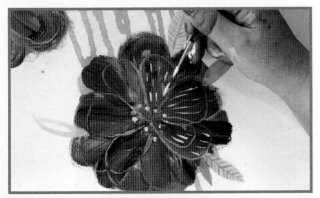

16 While studying the actual flowers, you can see the color variation in the petals. I'm choosing to stylize this with deliberate small white marks. Any way you can infuse your own quirky style into painting makes the paintings that much more rich and reflect you!

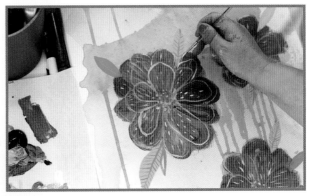

17 Bring some of the white petal detail onto the edge of the flower to integrate the bloom.

Creating a Nature Mandala

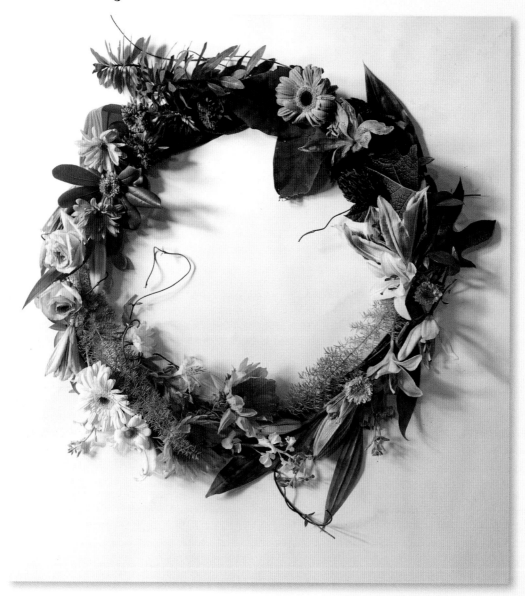

WHAT YOU'LL NEED

natural materials—gathered or bought, a variety of color and shapes to choose from

neutral work surface (paper or fabric)

scissors

My process is first about wandering through my yard, finding a feather in the grass, a just bloomed flower, acorn tops, fallen leaves. In winter, when there is not much variety of natural growth, I sometimes buy materials to create with. In this demo, I'll show you how to create a simple circle nature mandala. It's as simple as it sounds, and there really is no wrong way to do it!

Once you have finished creating your mandala, you might want to document it with a photo. I typically do this and then leave it. The materials within the mandala begin to wilt and decay within an hour, but the process and act of creation remain inside of you. The creation of the nature mandala becomes not about the finished product but about the calm and focus that you take away from the act of creation as well as about the new way of seeing that the practice brings.

1 Look at your materials and lay them out, placing like with like so you can begin to see what you have to work with. Begin your design by laying out the basic shape of your circle.

2 Begin building your design starting with the darkest color; here I'm using a dark purple. Choose the largest leaf or flower in this color to function as a center point that will anchor the design. Build everything out from this anchor piece, working intuitively and dependent on the amount of material you've collected.

3 Begin working outwards, placing a color in the same family to the left and right of the center point; we'll call this your secondary color in this piece. Work toward creating a pleasing balance of pattern and color. Work with color here, as you would with it in your paintings.

4 Place a brighter shade of your secondary color to the right of your center point. Fill your circle in with any greens you have. In a nature mandala, greens usually serve as a neutral to balance and support the colors.

5 Lighter colored flowers—here, lilies and roses—in a few spots help fill in the pink areas.
 Use light materials directly opposite the circle from your darkest color. I'm filling that area in with white flowers here. In that same area I'm also adding a pop of yellow, a color that contrasts with the purple.

6 Look at your whole circle and give attention to areas that need more filling in. I'm filling in with light purple, more pink and more yellow. Stop when you feel a lushness has been achieved.

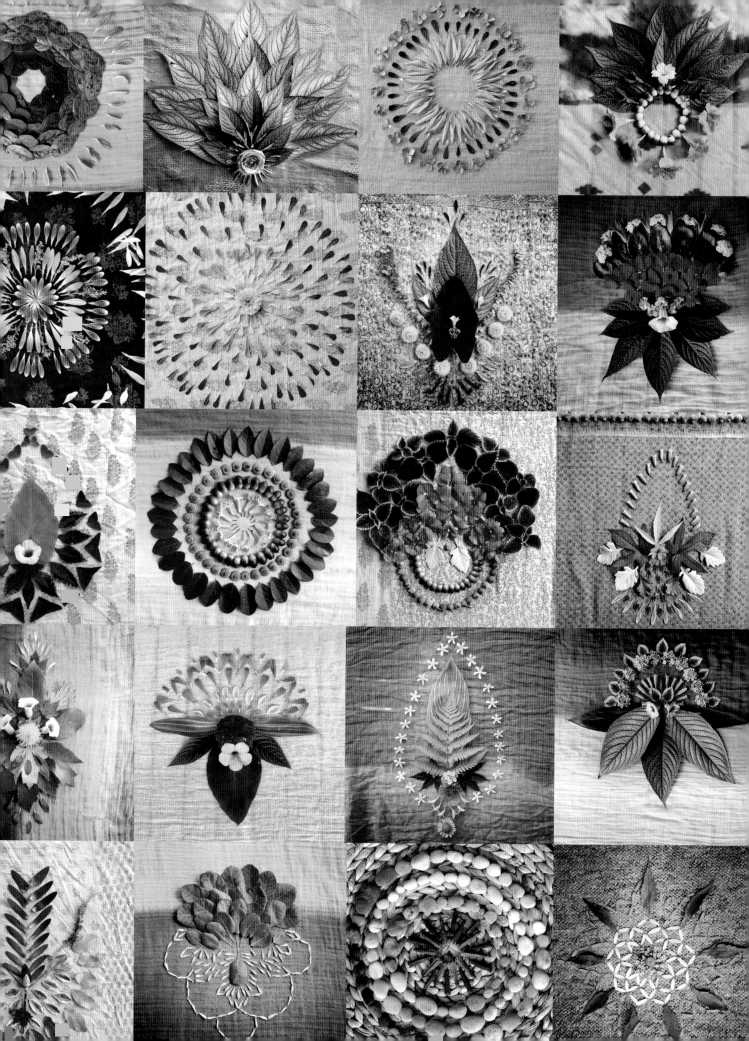

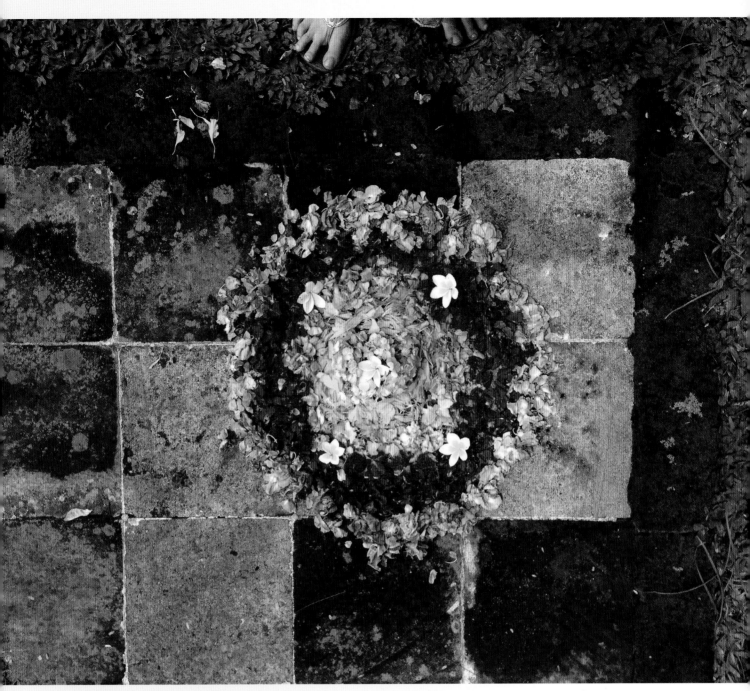

Nature Mandala Series with Gathered Materials
Faith Evans-Sills

Creating nature mandalas is a wonderful process to harness the inspiring power of flowers in your work. My nature mandala practice fuels my painting practice, bringing a lightness that reaches into every area of my life. Crafting arrangements with natural materials by layering a variety of shapes, textures and colors brings a calm state of mind that is open to creation. Working this way is a gateway to magic in the mundane, to divine inspiration. I call them mandalas, following the ancient tradition of using circular and bilateral patterns as a method of orientation and a connection to the cosmic harmonies of

the universe. Creating a mandala is also an act of meditation, requiring the creator to slow down and focus intently on creating a pattern where there wasn't one. I don't plan them out beforehand; they evolve organically with the materials at hand, and through them I feel the mysterious voices of creation and nature. These offerings celebrate life's bounty, they reflect what is otherwise inexpressible and they are an unspoken poem. Most of all, they are an invitation to others to join in the celebration of life.

　　—Faith

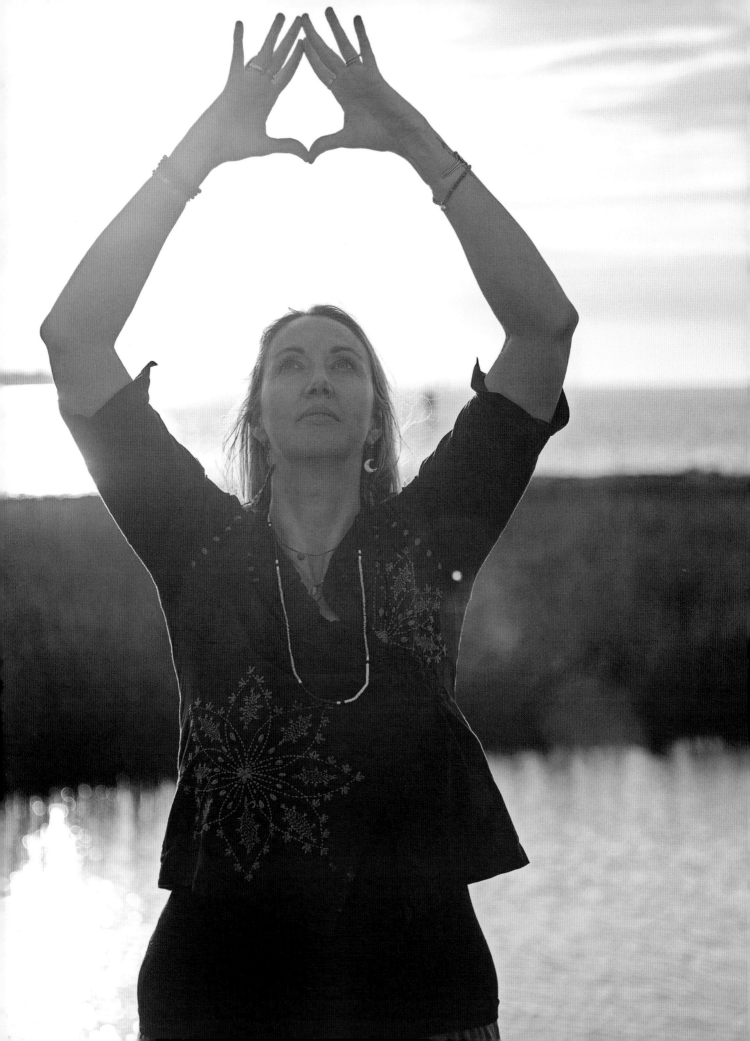

5 Finding Your Center
Building a Focal Point

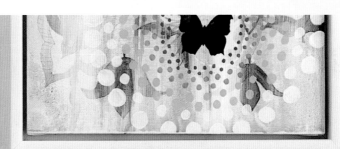
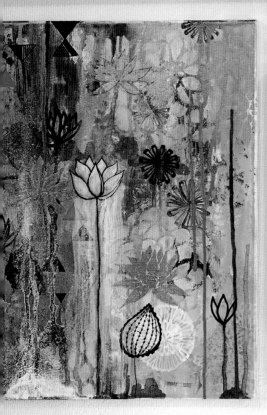
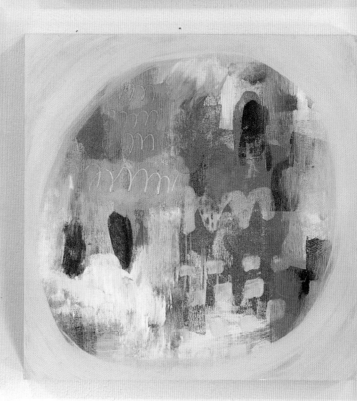

Finding your voice in your work is about accessing your deepest self and translating that into visual language. A great to go deeply inside and find what you respond to visually is by keeping a sketchbook of your doodles. By looking at the sketches that you make when your mind is completely relaxed, you can see what inspires you on a deep level. This is a good indication of the forms you are innately drawn to, what is most important to you. Since my teen years, I have made doodles of mandalas, swirls and paisleys with intricate designs, so when I was first introduced to Indian wood blocks, I felt a kinship aesthetically.

By exploring different types of mark making in relation to these designs, I have used them to build up rich layers in a painting.

I work with these elements through varied types of mark making, using a light wash to begin each piece then bringing in the line of hand-drawn elements, the heaviness of darker, opaque colors and a rhythm that comes with layering these varied ways of working.

I always try to keep myself loose and brave while working. Trying not to get precious right away when I see something I like developing in a piece is hard but usually benefits the piece in the long run.

One of the most rewarding parts of living an artistic life is connecting with others when they respond deeply to something you have created. When you are connected to the source of inspiration, what you put into each painting is no less than a piece of yourself, and when someone responds to the work strongly, you can find deep affirmation and clarity of purpose. My thought process can feel so multilayered most of the time, and I often think that is what drew me initially to work in this layered way. Seeing glimpses of the early layers in the finished piece is something I really respond to. Few things make me happier than when I find out I have inspired others to create something beautiful. I've always loved this quote by the talented filmmaker Maya Deren, and I think it sums up so much about the rewards of an artistic life: "What more could I ask as an artist than that sometimes, however rare, your most precious visions assume the forms of my images."

At the still point of the turning world...there the dance is.
—T.S. Eliot

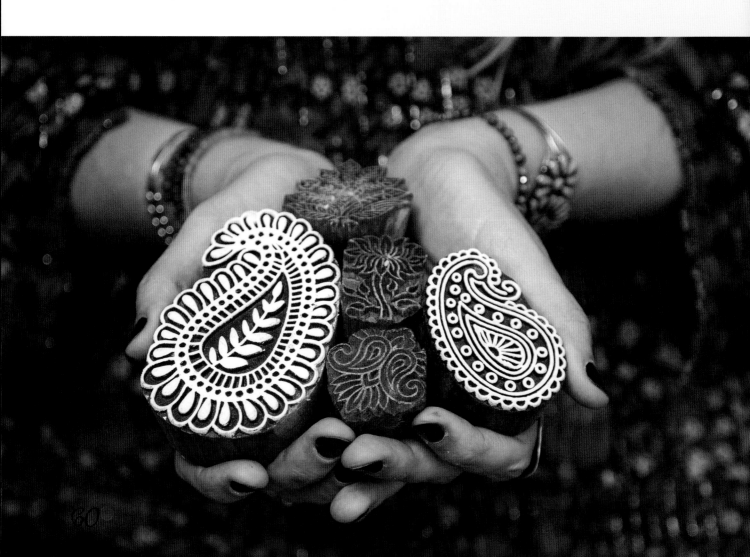

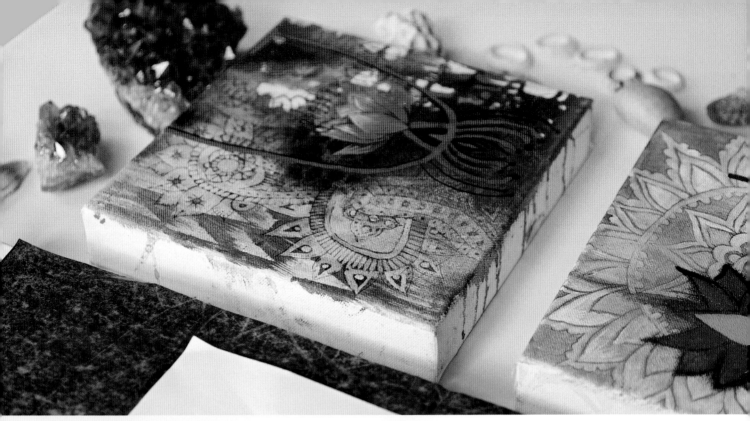

Bali Series
Faith Evans-Sills

When exploring primary and secondary focal points in a piece, one of the most important elements to consider is a certain harmony throughout. I know a painting is finished when I can step back and feel a pleasing sense of balance within a piece. With each painting, the timing may be different; sometimes balance is achieved after only a couple of layers, but with others you may find yourself working for days (or months!) until it feels right. As with any intuitive process, you will learn to just know when you've achieved what you need to in each piece.

For me, there is a moment when I survey the whole—the mark making, the imagery, the open areas of color—and it just feels right. That's when I stop working on a piece and put it aside to do other work. I'll come back to the piece in a few days, a week, or even a few months with fresh eyes, and if I still feel that sense of balanced harmony, I know I am done.

Sometimes I will intentionally build up the layers in a painting to create a busy, almost chaotic feeling that I will then rein in by adding a central focal point. I started doing this with the white lotus flower as a symbol for calm quiet, creating a moment of reflection within the piece. The quote "No mud, no lotus" by Thich Nhat Hanh runs through my mind often, with all the layers of meaning it brings. The lotus is a symbol of strength in the darkness for me, one I return to again and again.

—Faith

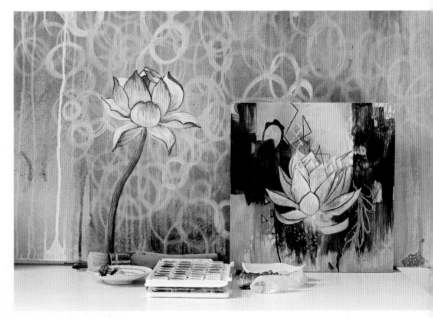

Hope and Nightfall
Faith Evans-Sills

Transferring Drawings to Canvas

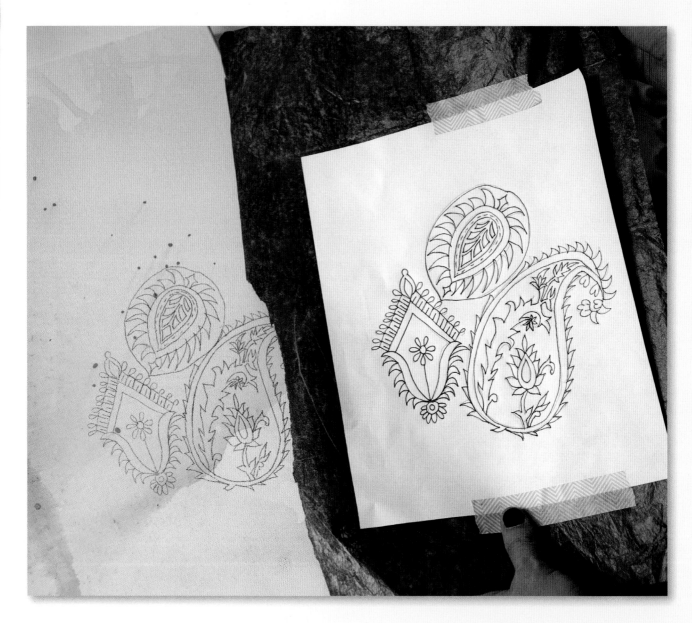

WHAT YOU'LL NEED

canvas, prepared for you to draw on; I'm using one with a pour, per demo in chapter 3

drawing you'd like to transfer (look through your sketchbook for something that inspires)

pencil, sharp

transfer paper

One of the shortcuts to bring your deepest self into your work is by taking your drawn explorations of your favorite shapes and forms, your doodles and sketches, and transferring them directly onto your canvas. Using this transferring process as a first layer allows you to build light layers on top of your drawings. Like pouring a wash of paint on a blank canvas, transferring your own drawings onto the canvas as a first layer is a wonderful tool to conquer any fear you may have in approaching a blank canvas.

1 Lay your canvas, or other surface, flat and decide where you'd like to place your drawing.

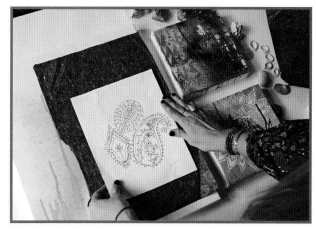

2 Place your transfer paper carbon-side down onto your canvas, and place your drawing on top of it. It can be helpful to tape both layers down so nothing slips while you are tracing.

3 Using your sharp pencil, trace over all of the lines on your drawing you wish to transfer.

4 When you carefully lift up the transfer paper, your drawing will now be transferred onto your canvas.

DEMO WITH FAITH
Exploring a Focal Point

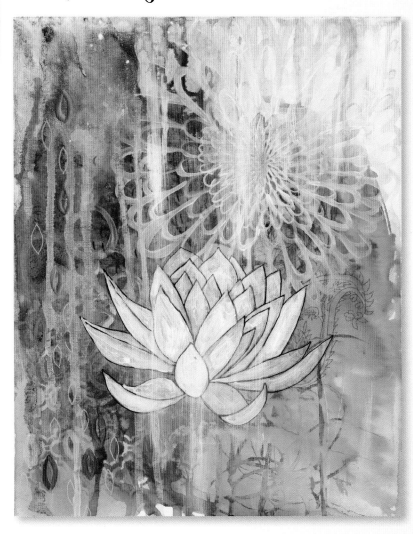

WHAT YOU'LL NEED

acrylic paint markers

acrylic paints: Titanium White and a variety of colors

canvas with transferred drawing from previous demo

paintbrushes, a variety of sizes

palette

permanent marker, fine-point black

rag or paper towels

spray bottle full of water

stencil brush

stencils

water

watercolor crayons

watercolor inks

Now that you have learned how to transfer a drawing onto a canvas, let's begin actually creating a painting by first building up some light layers. Think of these initial layers as a light and loose way of working that extends to your mind-set as you lay down these first layers, and feel into your energy—a way that I like to work with the washes and painting out the early layers of a piece. Remember, tight details can come later; just keep it loose for now. This is also a good time to practice detachment from the layers. Areas that you'd like to develop may emerge, but do not get precious with them at this stage. I have seen over and over again that by remaining light and loose, and let the painting unfold, unexpected moments occur through the layering. That's always where my favorite things happen in the work! In the first layers, it's important to remember to keep it fun and playful; don't focus on the end result at this point.

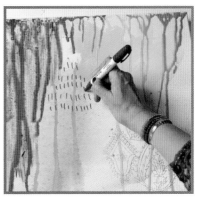

1 Put a few bright paint colors onto your palette and begin painting them onto your canvas. Use your large brush to paint an area completely in one color.

2 Drip two other colors thinned with water to down the front of the canvas.

3 We'll be building up a variety of marks in these layers to create a rich jungle-like feeling. Choose an acrylic paint marker and create an area of small lines or dots.

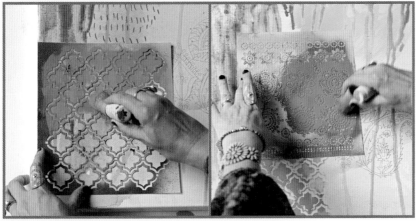

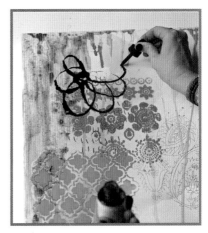

4 Grab one of your favorite stencils and your round stencil brush. Cover the tip of the dry brush with paint and dab it onto the stencil. Layer this with a different stencil in the same paint color, carefully lifting off the stencil when you're happy with the area covered.

5 Chose a watercolor ink in a dark color to add contrast. Fill the dropper with pigment and slowly squeeze it out as you swirl the dropper around on your canvas, creating flower petal shapes.

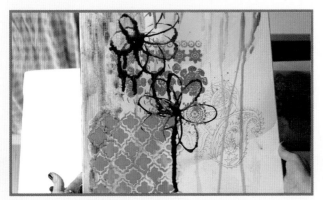

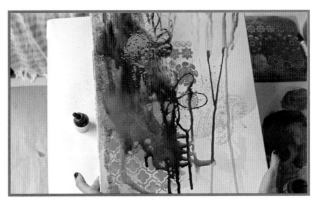

6 Raise your canvas to allow your paint and ink to run in wonderful drips.

7 Laying your canvas flat again, use your spray bottle of water to spray some of the drips so they become puddles of color. Raise your canvas again, allowing everything to run and flow.

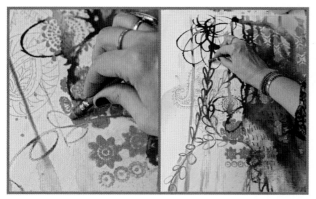 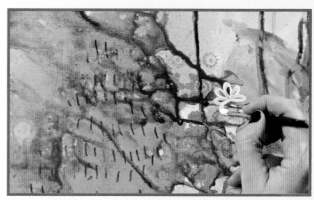

8 Create some more ink flowers if you like, then take a watercolor crayon and draw some botanical forms. I'm drawing some vines climbing up some of the drips, adding to the jungle-like atmosphere. Allow these layers to dry so your painting does not become muddy with too much wet paint.

9 Once your layers are dry, choose one of the upper areas of your painting to begin adding your first focal point. With white paint and a small brush, start by painting a small flower with eight teardrop-shaped petals.

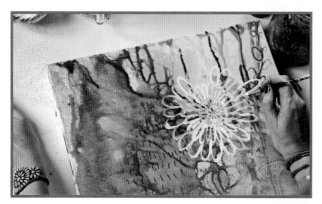 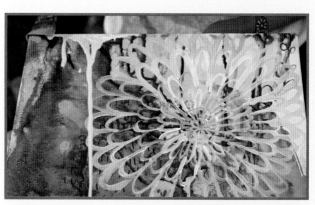

10 Continue building this focal point into a large mandala-shaped flower by painting teardrop-shaped petals around your smallest circle of petals, moving outwards in layers, forming bands of petals and growing your circle outwards.

11 On your fifth layer, switch to a slightly different color; here I added a bit of orange to my white, creating a subtle peach. This large mandala flower will become your secondary focal point. Add some watery drips next to your mandala flower.

 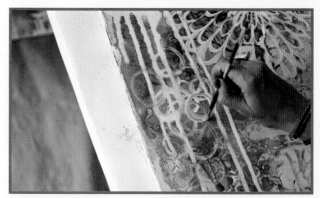

12 Your transferred drawing and other initial layers are still there, peeking through. Take a moment to check in with the painting. Step back and find areas you want to preserve, which will add depth and show the history of your painting.

13 To continue building up the lush layered feeling in your painting, add circles onto your drips like flowers growing on vines. Choose another color and add some circles in that color.

14 Add another layer of colored petals onto your mandala flower. It will really start to look like a mandala form at this point.

15 Now you will begin to build your primary focal point. Using pictures of a lotus flower for reference (or any flower of your choosing), choose a spot slightly lower than the center of your painting. Use your pencil to sketch in the petals of your flower, starting with the center. Try to have the upper petals of this primary focal point flower overlap the lower petals of your secondary focal point flower.

16 Using a small brush, paint some of the petals of your flower with a watered-down layer of white.

17 Using an acrylic paint marker or permanent marker, trace over the lines of your drawing. This will give your flower definition and differentiate the petals from the background.

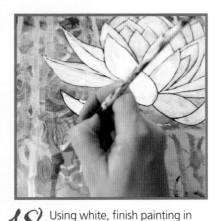

18 Using white, finish painting in your petals.

Next to your primary focal point flower, add a grouping of organic shapes, all in the same color family. I'm using oranges and yellows to contrast with the blue background as well as to give them a color relationship with the pinky peach of the secondary focal point of the mandala flower.

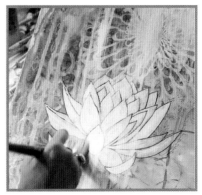

19 For your final layer, use your large brush and Titanium White to paint a thin layer of white on top of a few areas of your painting. Begin in the top corner near your secondary focal point, slowly adding thin layers of white to add softness and subtlety. Work slowly. If you feel you have added too much white, simply wipe it off with a wet rag or paper towel.

Bring some of your thin white layers down from the top of the painting over parts of your primary focal point. This will bring balance to your entire painting.

To get you inspired, here are a few more examples of this type of focal point in a layered painting.

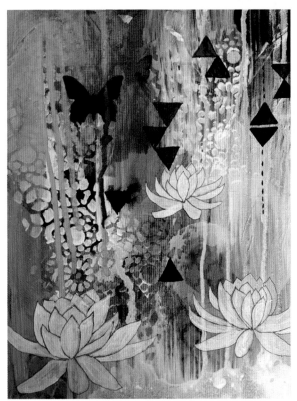

Sacred Shift
Faith Evans-Sills

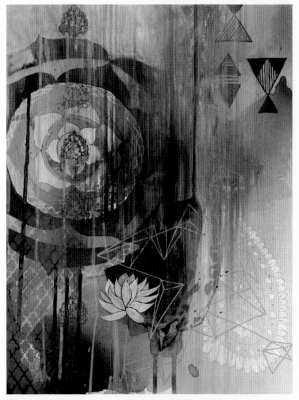

Cosmos
Faith Evans-Sills

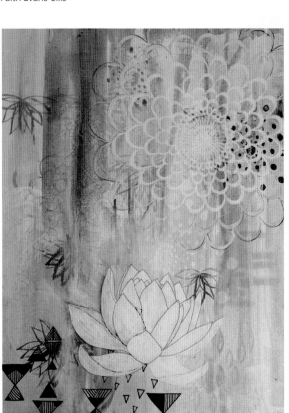

Universe
Faith Evans-Sills

Begin
Faith Evans-Sills

To Inspire You

JO KLIMA

We reached out to Jo Klima because of her skill at working with a strong focal point in her intricate pieces. We asked her to talk about why she is drawn to create mandalas.
—Faith & Mati

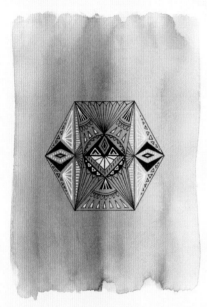

Geometric Hexagon
Jo Klima

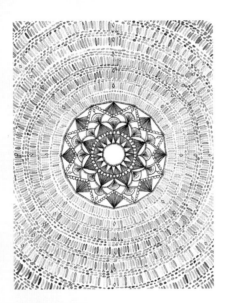

The Beginning
Jo Klima

Geometric Triangle
Jo Klima

What first drew me to create mandalas was a love for geometric and feminine shapes in my design work. A few years ago, I really needed to find my own creative outlet—something separate from client work. At that time I was starting to go deeper into my own spiritual work. The combination of the two meant that using mandalas in my artwork also provided me with a mindfulness practice that could add to the benefits I received from meditation.

I primarily draw mandalas in black pen, occasionally using watercolor as an accent or as a simple background. More recently I've also painted larger ones with acrylics on big canvases. For one of these larger pieces, I carved rubber stamps so I could repeat the patterns more easily.

I usually have a theme or intention in mind before I begin, which tends to influence the style and colors I use. Sometimes I'll draw a grid, particularly for larger pieces, but other times I'll just draw freehand. They usually start from the middle and span out from there. I enjoy making them quite intricate. When I look at them as a whole, there are definitely certain lines and patterns that I love to use again and again.

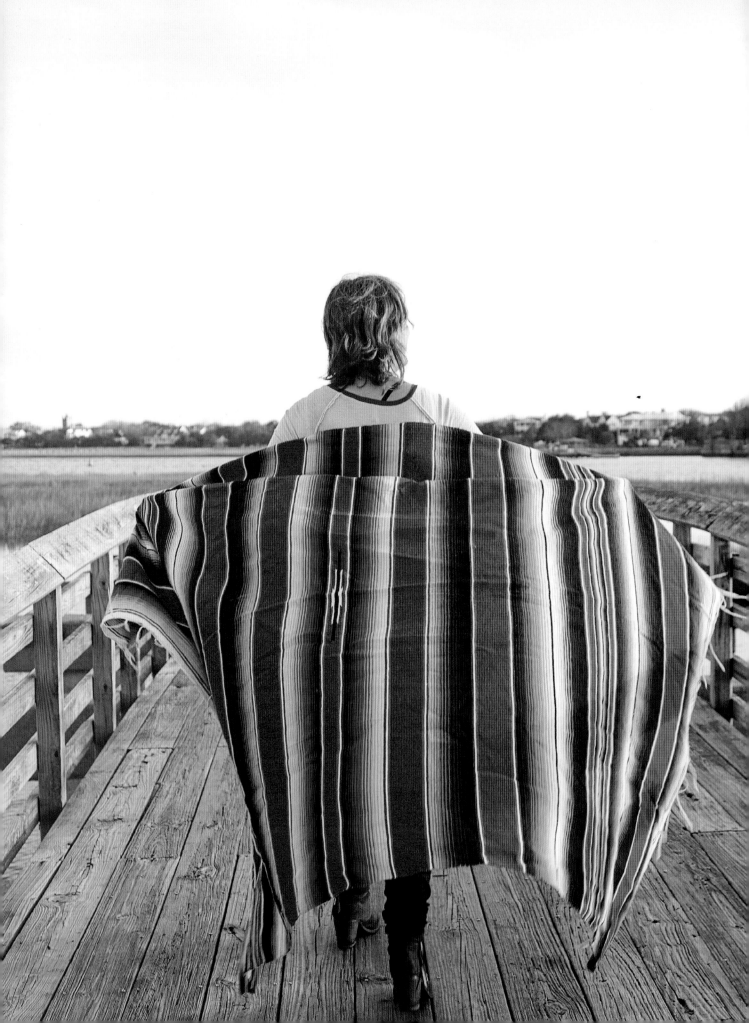

6 Creation as Meditation
Painting Mandalas

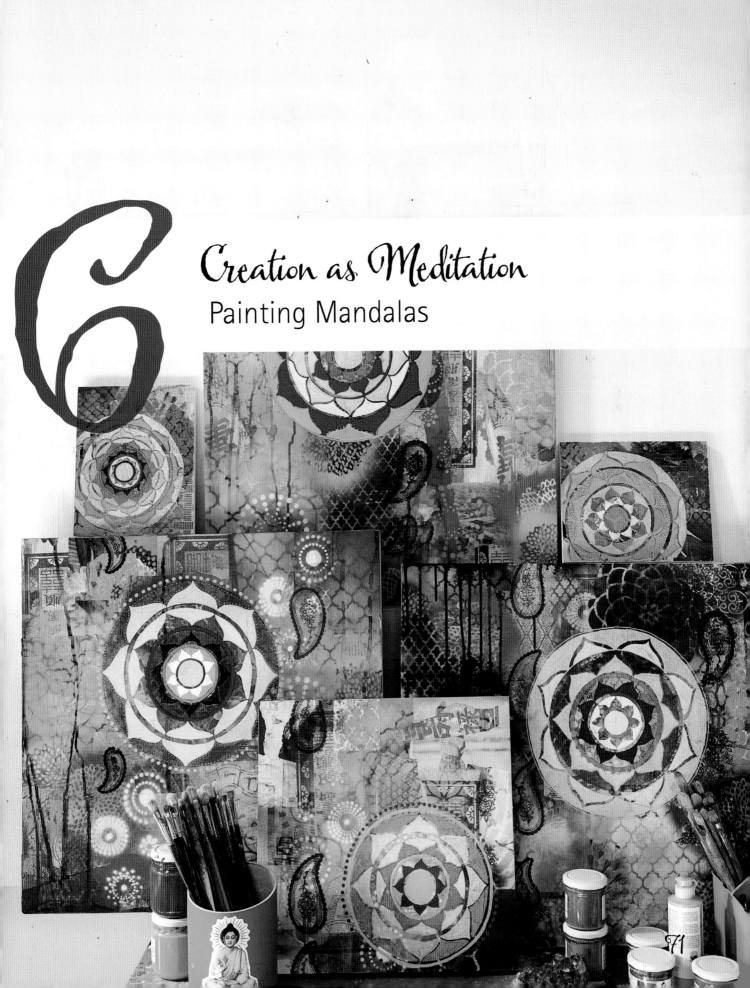

As an artist, using mandala making within your painting practice as a creative and meditative tool can assist you in accessing your deepest self and fueling the creative fire within you. Following the ancient tradition of using concentric circular patterns as a method of orientation, mandala making offers a spiritual practice and a connection to the cosmic harmonies of the universe. Traditional peoples all over the world use mandalas in rituals as a way to mediate contact with the sacred and honor the power behind life's mysteries. Creating them brings me into a calm state of mind that is open to creation, while at the same time draws focus and reflection. I find that whatever I am focusing on mentally as I create my mandalas takes over the forefront of my mind, so it is important to set my intentions for the day within this practice.

> Each person's life is like a mandala—a vast, limitless circle. We stand in the center of our own circle, and everything we see, hear and think forms the mandala of our life.
> **—Pema Chödrön**

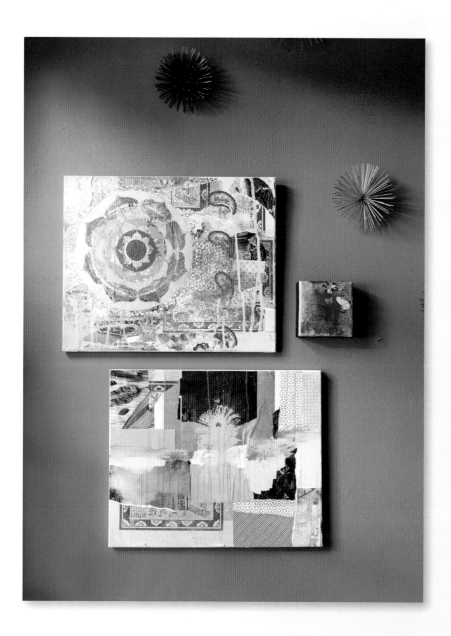

Choosing to bring your attention and focus onto whatever thoughts sit at the forefront of your mind as you work is a simple way to transform your mandala art into a meditation practice. Often what I choose to focus on is gratitude and celebrating all of the positive elements in my life. I have read that taking a moment each day to remember what you are thankful for, cultivates new pathways to happiness in the brain over time. So, as we begin this painting, I invite you to create a gratitude list. Let us think about radiating our internal gratitude out into the world toward those people and things we are so grateful for. I find that this brings me into a state of calm focus.

In the demo that follows, as we journey together through the three-layer process that I use to create my layered mandala paintings, I'll give you all of the techniques you'll need to create your own layered mandala paintings. You'll add delicious textural layers and personal flair as you introduce all of these techniques into your studio practice. I believe you will find (and love!) the fact that no matter how many times you follow these same steps, the end result always changes, as there are endless variations within the layers.
—Faith

Layered Mandala Painting

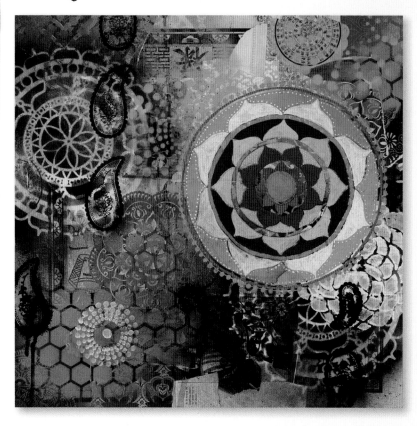

WHAT YOU'LL NEED

acrylic medium (Mod Podge or gel medium)

acrylic paint, a few colors

acrylic paint markers, a few colors

canvas or wood board (such as birch board from the hardware store), approximately 24" × 24" (61cm × 61cm)

collage papers (any kind of paper you have on hand will do; magazines work great)

old credit card or hotel key

paintbrushes, a few large

pencil, sharp

silkscreens

spray paints, a few colors

stencils

tape

transfer paper

water and water container

We'll begin our layered mandala paintings by creating a collage background. Collage backgrounds can be a wonderful tool to use as a go-to first layer in your studio practice, to get things flowing and to conquer that fear of the white page. By putting down a collage layer quickly, you can step forward into the work, not thinking at all about the composition, simply grabbing papers that feel good to you. Choose papers that resonate with your intentions of gratitude or whatever you choose to focus your attention on as you work.

I've got a huge collection of collage materials that I've gathered over the years in my studio (you probably do, too), so it's easy for me to pull out some papers and get to work.

For the second layer, we'll use spray paint and stencils, then we'll add painted elements with silkscreens.

LAYER 1: COLLAGE

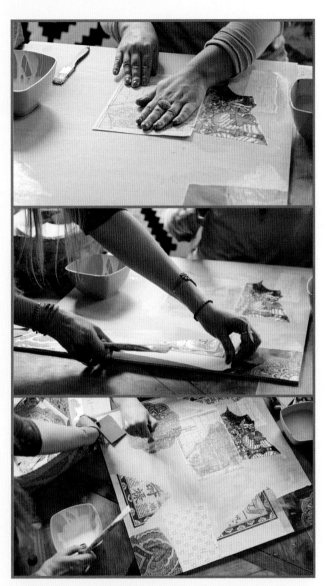

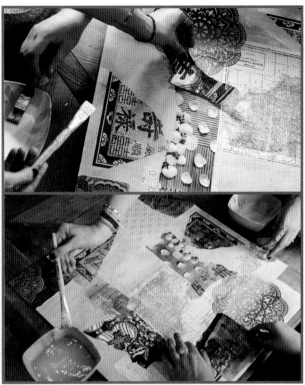

2 I like to tear one eye-catching piece of paper into a few large pieces and use it in a few different areas of my piece to energize the composition as the eye moves back and forth between the pieces of paper. This bright gold paper is a good choice for this.

1 Have ready your collage paper stash, adhesive (acrylic medium) and water. Each layer builds on the last and really loosens you up, getting you ready for what's next! This layer is all about staying loose and open to change as you layer your papers. Try not to begin with a pre-conceived idea of where you're headed with the piece; rather, allow it to evolve organically.

Wet your brush with water and dip it in the medium, brush a thin layer of adhesive onto your surface, choose a piece of collage paper and stick it to the surface. Brush a thin layer of the medium over the top of the paper to seal it.

This initial collage layer can be a fun collaborative layer to work on with a friend.

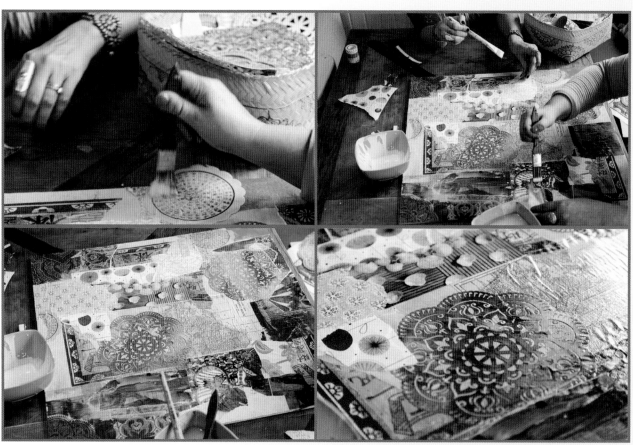

3 Focus on working all around the piece, out to the edges, and filling in any empty spots as the surface is covered. When you're finished, and you look at what you've done, you can see where you are internally just by glancing over the images and pieces of paper you've chosen. In this way I feel like these collages can function on their own as a vision board, offering us insight and wisdom.

LAYER 2: STENCILS AND SILKSCREENS

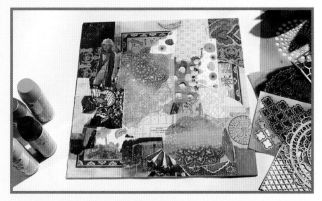

1 If you can, take your painting and a selection of stencils outside for some spray painting. Spray paint should always be used in a well-ventilated area (such as outside), and it's not a bad idea to wear a ventilator mask as you spray.

2 Starting in one corner of your painting, spray through a larger stencil and move diagonally across the piece, moving the stencil.

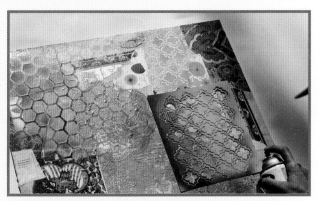

3 Next choose a different pattern, similar in size to the first, and create a line of this pattern through the painting in a different color.

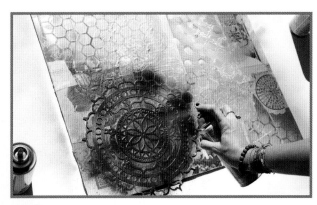

4 Add a few larger stencil shapes, repeating them in a couple of spots around the painting.

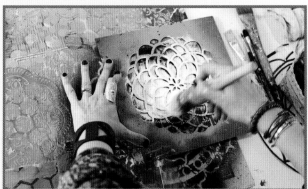

5 Try adding some variety to your marks by using a large, blunt bristle brush to paint through a few stencils. Using white paint adds a nice neutral in a painting with a lot of color.

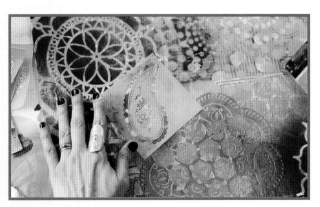

6 Now grab your collection of silkscreens, choosing one and laying it down on your painting with the sticky side of the silkscreen facing down.

7 Put a small amount of paint onto an old credit card or hotel key to use as a squeegee.
 Heavy-body acrylic paints work best for this step.
 Carefully scrape the paint over the image on the silkscreen with your squeegee, cover-
 ing it entirely with the paint, then carefully pull away the silkscreen.

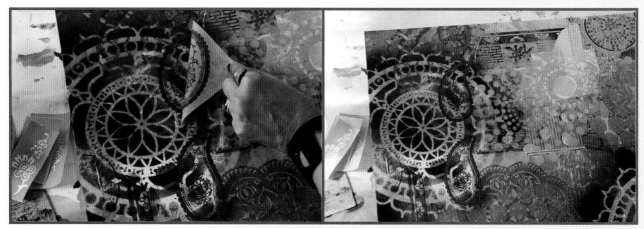

8 I like to use silkscreens to create a repeated pattern of shapes, like this line of paisley forms
 all in the same color and size. I'll also add continuity by repeating this same shape in a dif-
 ferent color and size in a couple of other spots around the painting.
 Experiment with your own patterns and decide what feels right for you.

LAYER 3: PAINTING YOUR MANDALA

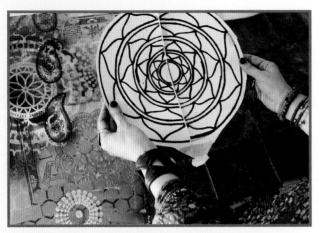

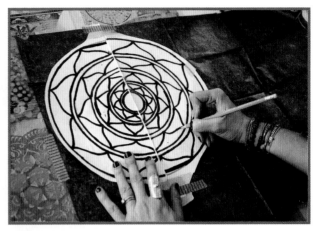

1 As you prepare for your final layer, it's time to think about where you will add your mandala. I've included a hand-drawn mandala template for you to photocopy and use for this step, and if you wish to use it, make two copies or scans of the template now. (Pattern is in the back of the book.)

At this point in the painting, it usually becomes clear to me where I want to place my mandala; often there is an area that feels less resolved, and this is where I place it. Take your two copies of the mandala template and tape them together to form a complete circle. Alternatively, you could make your own design on white paper, using a black pen. With your mandala template in hand hold it up to different areas while picturing and thinking about where your mandala will look best.

2 Gather carbon or transfer paper, a sharp pencil, tape, acrylic paints, small brushes and paint markers. Lay your transfer paper carbon-side down on your painting and place your taped-together mandala on top. It helps if you tape the transfer paper and pattern together. Then using your sharp pencil, trace over the mandala image. Once you finish, lift up your transfer paper to reveal the transferred image underneath.

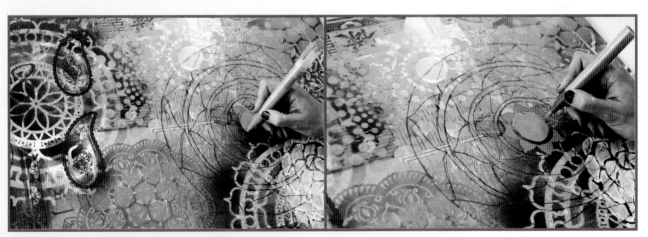

3 Now it's time to begin painting your mandala. Starting at the center of the mandala, use an acrylic paint marker or small brush to paint the center circle with one color. Fill in the petals around the center with another color.

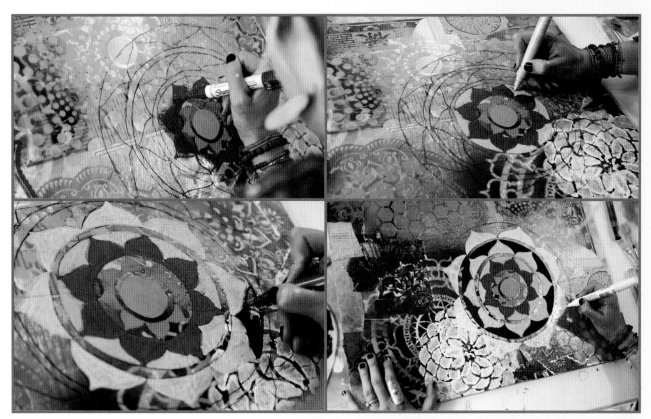

4 Continue filling in the petals of each layer of your mandala with your paint markers or small brush and acrylic paint. Leave areas in the pattern unpainted; these act as windows through the mandala back to other layers of the painting, adding depth to your piece.

When choosing colors for the petals of the mandala, consider picking up colors that you used in the other layers of the painting.

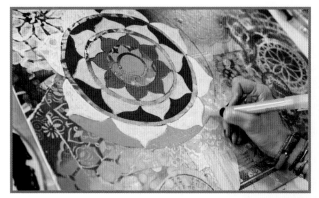

5 For the outermost layer of my mandala, I like to use the same color that I used in the center circle; I find that this unifies the entire pattern.

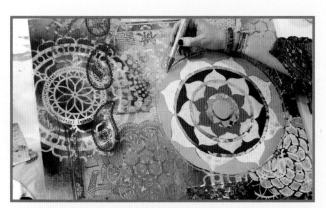

6 Look at your piece and decide if it's finished. Here, I finished off my painting with a bright layer of pink surrounding the mandala, along with some dot painting within my layers to add interest.

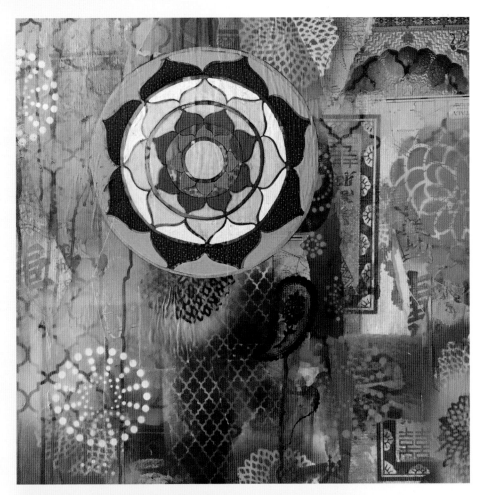

The Midnight Season
Faith Evans-Sills

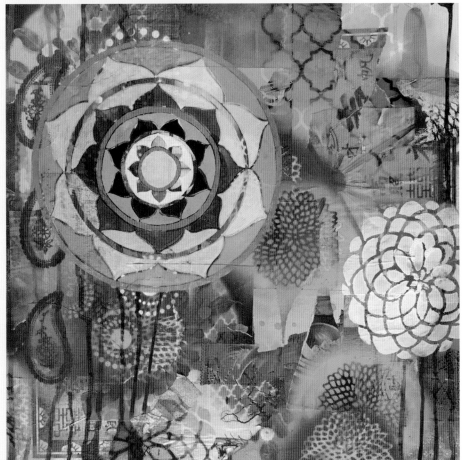

Dreaming Out Loud
Faith Evans-Sills

It is exciting how every time I complete one of my layered mandala paintings, it always has such a different color story and feeling, even though I use the same three-step layered painting process and techniques to create each one. I love the life metaphor within this, that although you repeat the same steps, you will never get the same result twice!

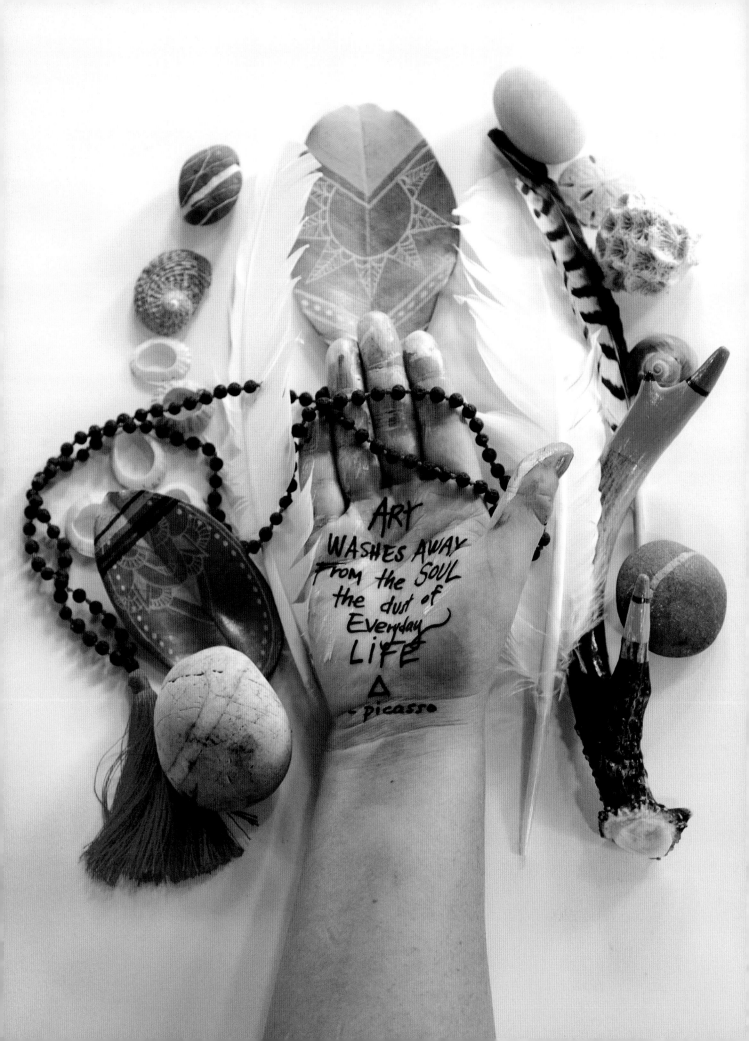

7 Hearing the Inner Voice
Incorporating Words Into Art

Painting is like poetry; both mediums communicate deeply and need time and paring down to become complete. Poet T. S. Eliot said genuine poetry can communicate before it is understood. Painting is a visual language and when paired with words, becomes even stronger in communicating our inner world. In this chapter, we delve into incorporating words into our paintings. We explore how choosing a strong word can unify the theme of the painting and what you want to communicate in your art and life.

There's a common practice of choosing one word in the New Year as an intention for the year. This can actually be applied at any time of year, and choosing one word that is meaningful to you is a good place to start thinking about what you want to usher into your life.

Listen quietly to what word comes forth for you . . .
A word you most need to hear.

If you hear a voice inside you say you cannot paint, then by all means paint, and that voice will be silenced.
—**Vincent van Gogh**

A word you want to use to bring you back to center.
A word that grounds you to your core.
This word will act as your mantra and guidepost for making decisions when feeling lost as to what direction to turn. In creating a painting with this word on it, it will be a visual reminder of this sentiment with all the energy of the painting process combined.

Like your painting practice, a word of the year becomes an intention and relationship you build over time. It's an ongoing practice of connecting to the spirit of the word. If you sit with your word, you can more quickly center yourself and dive into your art. You can remember what your inner compass desires.

Sometimes it takes so long to land before starting a painting. To get into the space of creating. We feel stuck or anxious before we create. Pacing, cleaning and doing anything *but* sitting still and creating art. I find that in those moments, it's helpful to bypass the muck, the chatter, the chaos of life and remember this grounding word or mantra for yourself.

In the past I've started off teaching painting with students writing "love letters to themselves" directly on the canvas, then painting over the letter with that essence underneath for only them to know.

I Will Wait for You
Mati Rose McDonough

Sometimes words come at the end of a painting, or emerge as I'm painting, or sometimes I'll be listening to a song and those lyrics will come in. Often to get ready for a painting, I'll journal. Free writing, wild writing, circling words that feel pertinent along the way. I love the idea of just writing words in at any point and then painting over them or letting them partially emerge. There are no rules here. Ultimately we want the words to feel good and resonate. Another idea is to work on a painting you already have and are perhaps feeling stuck with, adding a powerful word to it.

I did some free writing, and these are some inspiring words that came to me: Blooming, Delicious, Surprise, Succulent, Wilderness, Possibilities, Grace, Abundance, Peace, Joy, Faith, Love, Trust, YES, Allow, Begin, BE, Belong, Dare, Center, Presence, Connection, Embrace, Explore, Savor, Ground, Gratitude, Journey, Open, Soar.

Before we move on to the demo, you may want to take a minute and free write words and ideas you have or borrow one of these.

—Mati

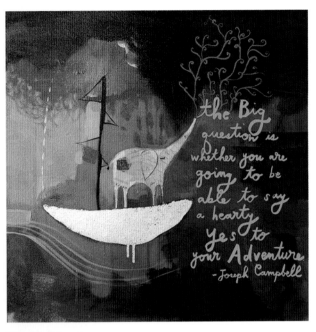

Hearty Adventure
Mati Rose McDonough

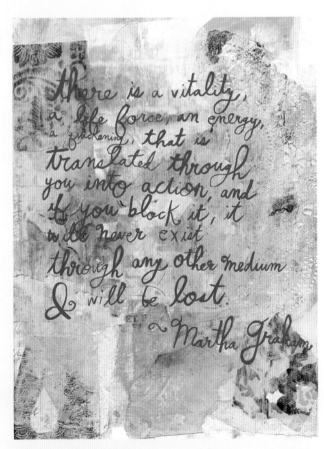

Martha Graham Quote
Mati Rose McDonough

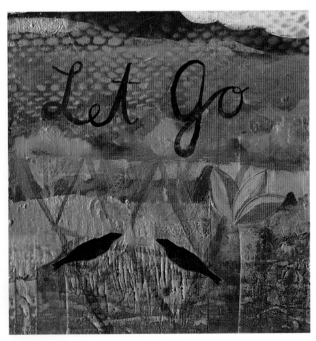

Let Go
Mati Rose McDonough

Lettering with a Brush

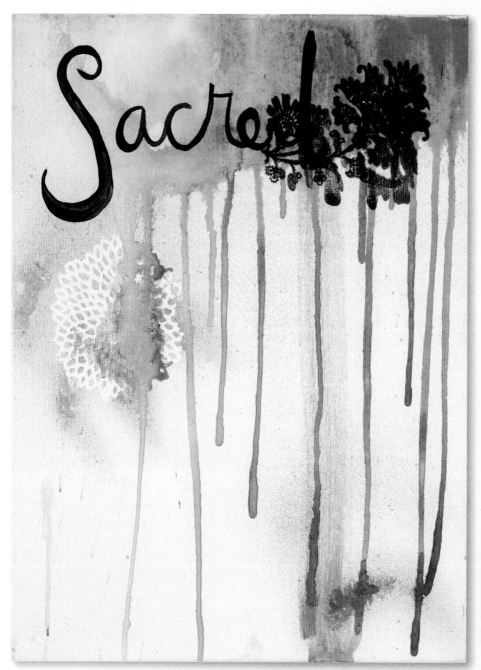

WHAT YOU'LL NEED

acrylic paints

marker

paintbrushes (small with clean, crisp tips)

water

Here we'll explore script as an elemental part of the painting. Your own font is another extension of your artistic voice. We each have a unique signature that carries a powerful weight along with its message. Lettering is your natural mark marking. When you combine your script with your artwork, you bring tremendous meaning to your painterly expressions.

In this demo, you will choose a strong a word to use as a continued theme and reminder of what's meaningful to you.

1 You may want to have a friend write your one word or a quote on your hand to fully embody the word(s).

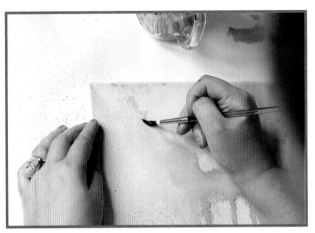

2 Using watered-down or fluid acrylic paint (sometimes I use water-resistant black India ink), start writing your word with a small brush.

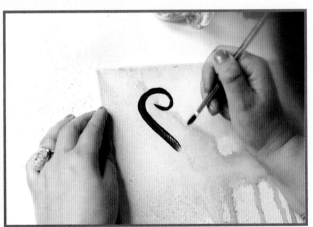

3 Begin the script, adding calligraphic elements like curves to the words. Think about where compositionally it works to paint the word in the painting— if there's a perfect clearing for the word or if you want to create one before you begin with a swath of paint.

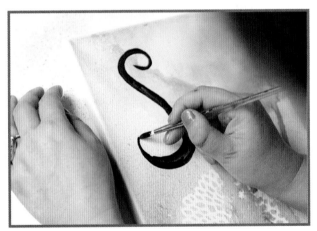

4 It's helpful to vary the width of the letters from thick to thin for visual interest.

5 Continue lettering in a fluid, cursive way.

6 Go over the script multiple times and treat the lettering as a word, but also as a painting by paying attention to the curves and varying the lines.

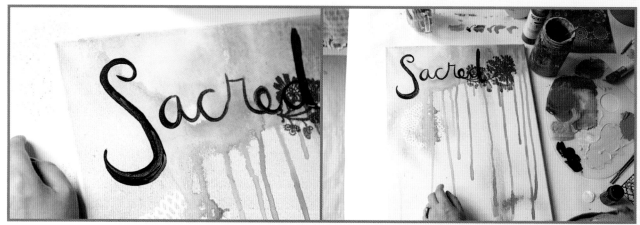

7 Finish your word, making sure it reads well and takes up the space beautifully.

To Inspire You

MARY WANGERIN

Mary Wangerin often uses exquisite hand-painted lettering in her paintings, inviting the viewer to experience words in a deeper way. We asked her how she chooses the words that she works with.
—**Faith & Mati**

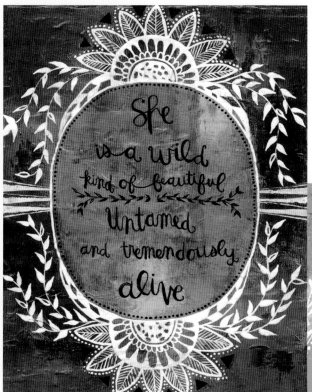

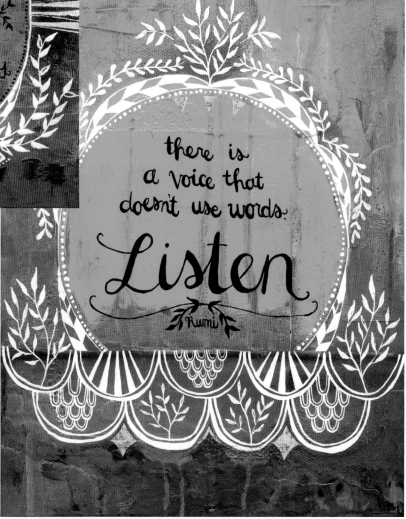

Mary Wangerin
I love to incorporate words or quotes into my work. Often, the words I choose tend to reflect how I'm feeling that day! They serve as gentle reminders, inspiration and guides. I believe in the beauty of imperfections and messes, so almost all of my lettering mirrors this! I grab a small-tipped paintbrush and go for it, rarely ever using a pencil first. The process is so freeing!

Adding Letters with Stamps

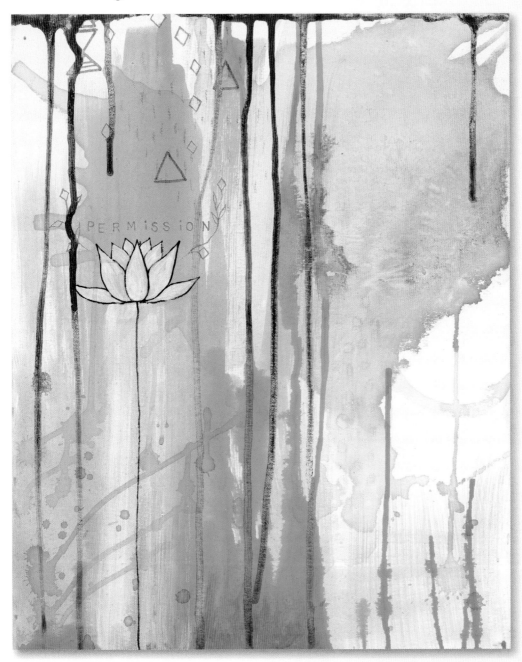

WHAT YOU'LL NEED

acrylic paint markers

acrylic paints, your favorite heavy-bodied colors

alphabet stamps, set of small letters

paintbrushes (small with clean, crisp tips)

When adding a word to a painting, I often use stamps. I keep a couple sets of alphabet stamps in my studio so when the mood strikes, I can grab them and experiment. I start by thinking about what word I'd like to add to my painting; this involves sitting with the piece and getting a sense of what feeling the painting is calling out to me as it develops. I enjoy using stamps to add the word to the painting as there is a clarity and simplicity that the stamped letters bring. The word looks almost like it was typed onto the painting, and I enjoy going back in and adding hand-painted details to ground my stamped word and integrate it into the atmosphere of the painting.

1 Get out your alphabet stamps.

2 It's helpful to first set aside all the letters of your chosen word to ensure you have them.

3 Use ink, or paint onto the letters directly in place of ink.

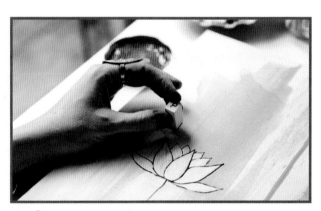

4 Stamp the letter where you'd like it to appear visually.

5 Here, I stamped the word PERMISSION because it's a word I'd like to remember.

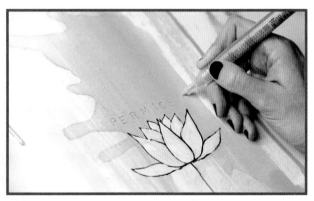

6 If the word ends up being lighter than you'd like, go over it with a paint marker.

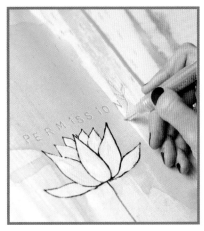

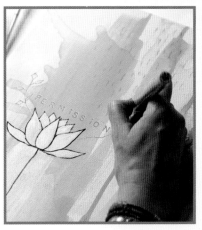

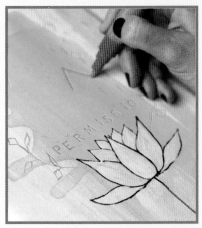

7 Add more ornamentation to the word to draw attention to it if you'd like.

8 Make the ornamentation symmetrical to bring even more balance to the piece.

9 Add additional mark making and geometrics to increase the visual interest and tie in the color of the word.

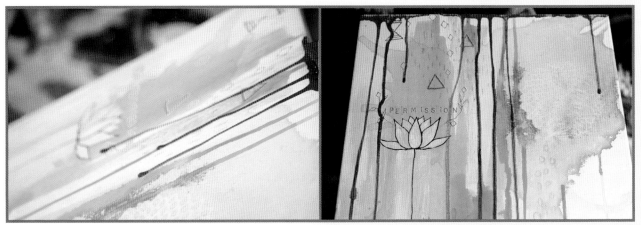

10 Use the dripping method (chapter 3) from the top of the painting to further tie in the color and composition of the piece, in this case the pink. Bring it across the entire top of the piece and let it drip down unevenly for visual interest.

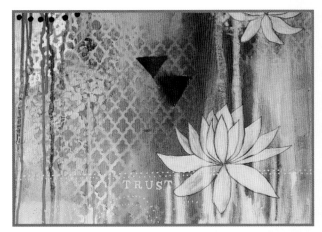

Another stamped word example.

Susa Talan

Our friend Susa combines words, art and text. She has a talent for keeping things minimal and spacious and we wanted to know how she does this in her work.
—Faith & Mati

WORDS THAT SPARKLE

My creative process changes depending on the project. Most often, I start with a quote or words. It's rare for it to go the other way around. Choosing the words, selecting or writing them, is its own process. There are so many poets, musicians and writers whose words have kept me company over the years, so finding authors is not the challenge. The hard part is finding quotes that pass something like a sparkle test—those that move me instantly, in some deep way with a hit of recognition.

Once I have some words, I look for a strong visual association. During my year long illustration and gratitude project from 2012–2013, I was working on a daily deadline, so I didn't have much time to rework an idea. If a quote with sparkle gave me an image, I ran with it and started drawing. If it didn't produce an image right away, I put it on hold and kept looking. During that year, I started right in on the drawing with pen. Never a pencil sketch first. I would just let it come out, often in one take. I appreciate the spontaneous feel of lines that aren't thought out first. In custom or editorial work, it can be quite different, and most often, I'll use a pencil to sketch the overall layout or specific elements (animals, people, objects), then go back into it with pen.

Increasingly, I include my own words in my work, which is both easier (in terms of copyright) and also a way to stretch myself creatively, to try to voice what I care most about in a sound bite or quote. My own words can come from anywhere: conversations with friends, thinking about something on a hike or ideas that bubble up in my own writing. I often write words down on scraps of paper, napkins or in the back of books.

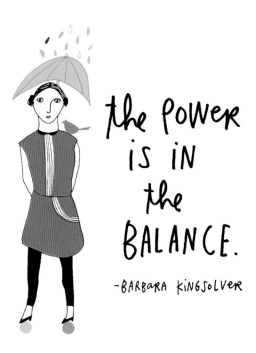

the POWER is iN the BALANCE.
-BARBARA KiNGSOLVER

Balance
Susa Talan

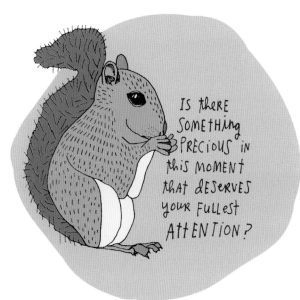

IS theRE SOMETHiNG PRECiOUS iN this MOMENT thAt dESeRVES youR FuLLeSt AttENTION?

Something Precious
Susa Talan

93

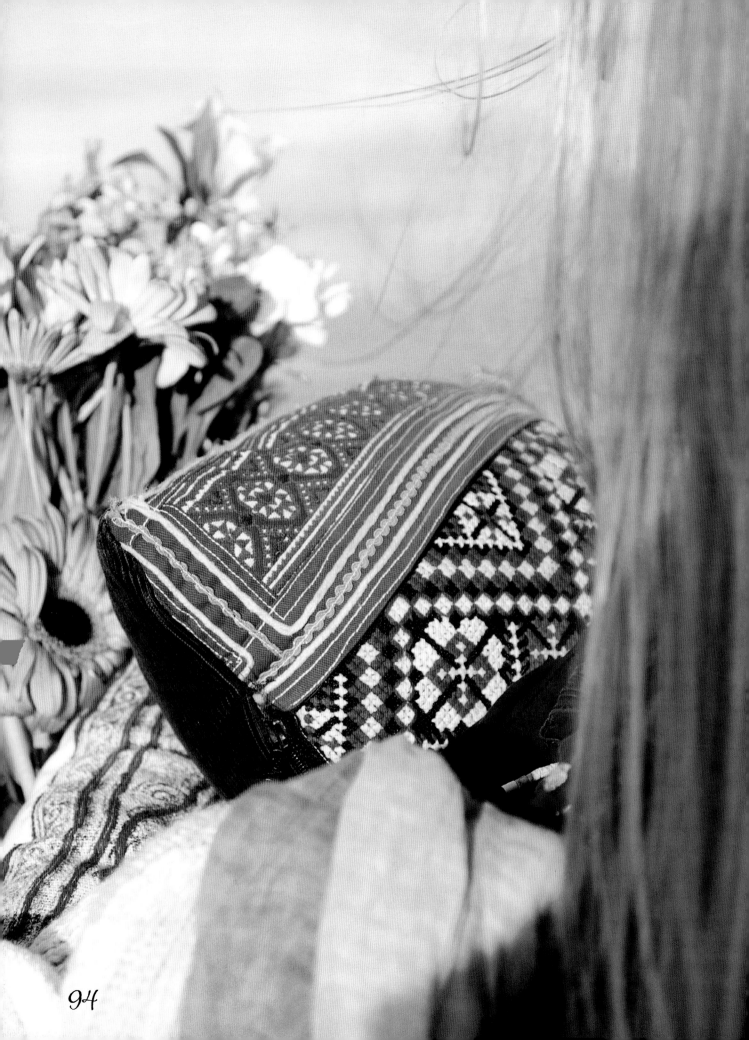

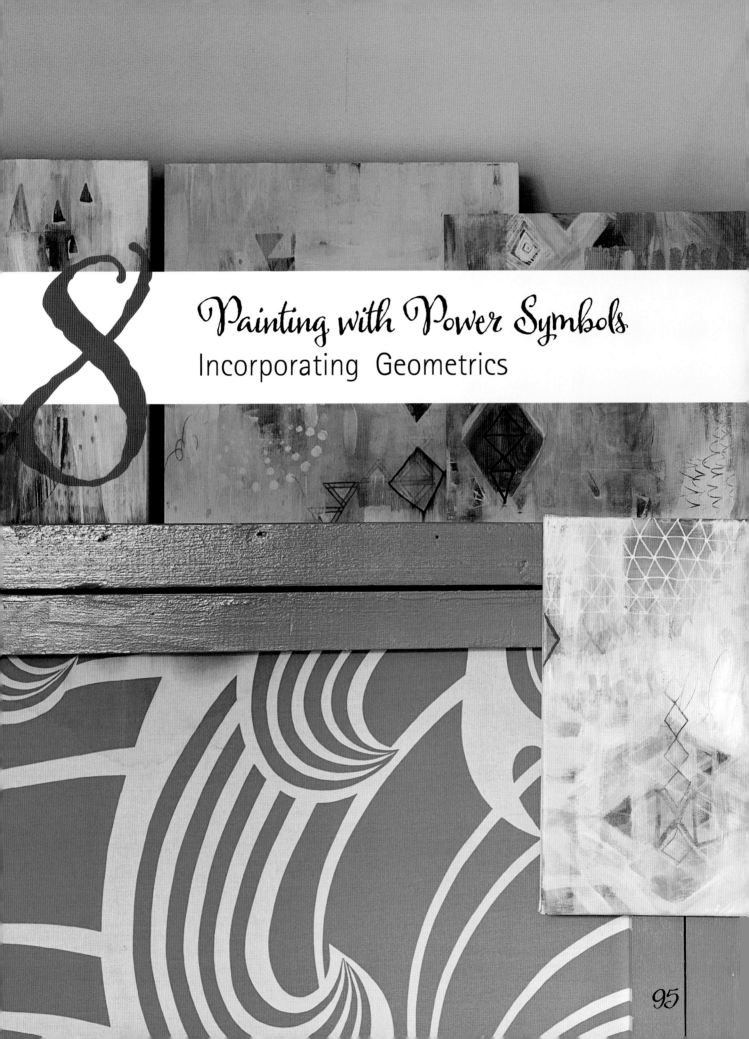

8 Painting with Power Symbols
Incorporating Geometrics

One of my favorite ways to play with color and form in a painting is to work geometric shapes into my abstract layers. In fact, simplifying your composition into the use of shapes is a fantastic trick to use as a starting point for creating an abstract painting. Combining clusters of geometric shapes with organic forms creates a natural sense of balance and contrast.

Geometric shapes are what most people think of as shapes; they come from geometry and are simple. Circles, triangles, squares and diamonds are made up of lines that are easily recognizable. These shapes suggest structure and symmetry; they are the opposite of organic shapes.

Organic shapes are irregular. They have more curves and are uneven. They are more typically representative of shapes found in nature such as a leaves, rocks and clouds. While geometric shapes are more precise, organic shapes are natural.

Throughout history, cultures around the world have used geometric symbols as a visual shorthand to communicate everything from love to power, worship, abundance and wealth. These symbols have been traditionally woven into textiles and painted on

> I found I could say things with color and shapes that I couldn't say any other way—things I had no words for.
> —**Georgia O'Keeffe**

surfaces. A simple Google search can be a fantastic way to find simple shapes and combinations that inspire you as a jumping-off point for your shape explorations. I find that the more I simply play with the different geometric forms in my work, the more possibilities seem to present themselves. Looking to your own work can be another great place to find shape inspiration. Sit for a moment in front of a group of your paintings, drawings or sketches and ask yourself, "What are the repeated forms, marks and images that I come back to again and again?" With your sketchbook on your lap, begin to draw out the repeated forms that jump out at you.

As you look longer, you will see and notice more; sketch and write about all of this so you can begin to use these repeated forms as a reference point when you are in your creative space. This is a great technique for developing a strong personal voice in your work. Through developing the shapes and marks that naturally appear most often in your work, you begin to notice your own innate voice in the things you are naturally drawn to. In chapter 12 we'll dive into this idea in depth as we help you

Triangle Power
Mati Rose McDonough

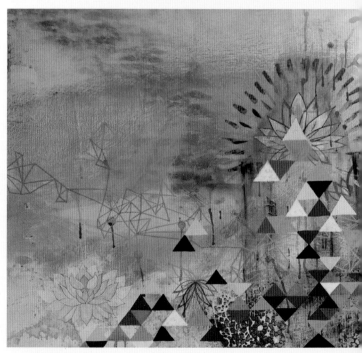

Mantra
Faith Evans-Sills

develop these shapes and forms into your own personal vocabulary of mark making!

There are so many ways to play with geometric shapes in your paintings. Here are some suggestions based on experimentation with a simple triangle:

- Use triangle forms inside each other.

- Place triangle forms next to each other and play with their edges touching and not touching; bring the edges right up against each other.

- Use free-floating triangles that feel like they are taking off. Ask yourself what sort of energy these bring to the piece.

- Experiment with light and dark by filling in your triangles with light and dark colors, both opaque and translucent. Darker, denser shapes create a heavier area.

- Create a lattice form by connecting the edges of triangles and not filling them in; this allows space for the shapes to breathe.

- Play with opposing triangles pointing in two different directions. Do this close together, then at opposite ends of your painting.

- Experiment with drawing the triangles freehand; then try using a stencil to draw them. Also try masking out the triangle shape with artist's tape; do you prefer a crisp or more natural edge to your shapes?
 —Faith

Working Geometrics into a Layered Painting

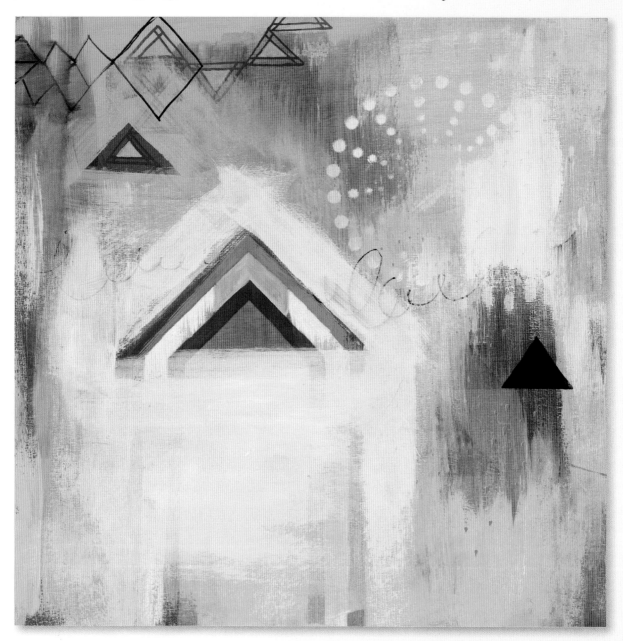

WHAT YOU'LL NEED

acrylic paint

acrylic paint markers, colors you like

canvas or wood board

paintbrushes, variety of sizes including a 2"
(5cm) flat

palette

pencil

stencil

water

In this demo, we will create a layered painting
that explores creating a natural sense of balance
and contrast by combining clusters of geometric
shapes with organic shapes and paint washes.

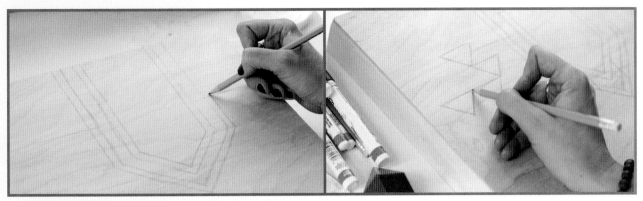

1 Use your pencil to sketch a few geometric elements onto your surface. The great thing about starting with pencil is that you can erase and start over if you want to! As you create these sketches, think about creating direction with line and form, as well as adding forms to many areas of the piece to spread around the composition.

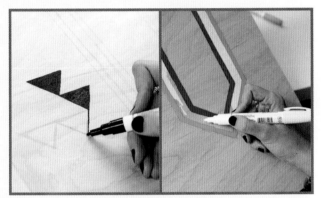

2 Once you are happy with the sketch of your shapes, fill them in with acrylic paint markers, giving them a density and opacity by painting in the entire forms.

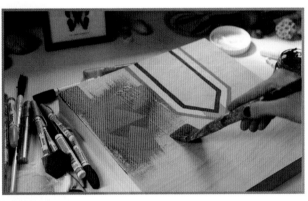

3 Using a large brush, create a transparent layer by watering down some bright paint. Add dimension to your composition by painting this transparent color over some of the shapes in the first layer.

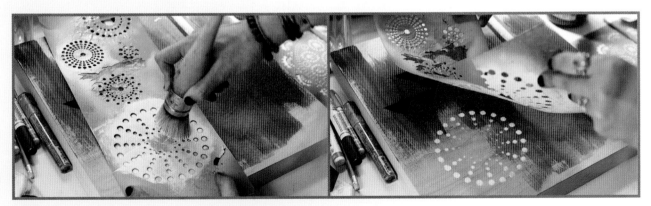

4 To add more interest and variety of marks, try using a stencil (I used a round shape) to bring a pleasing contrast to the hard-edged geometric shapes.

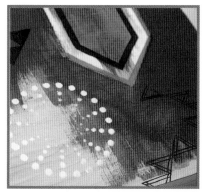

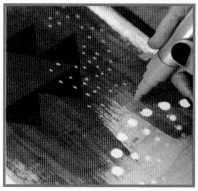

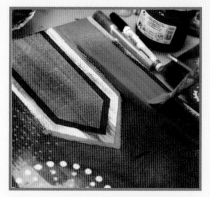

5 As you begin to build up a density of shapes, work back and forth between geometric forms and areas of looser color. Connecting shapes gives them an open, lattice-like feeling.

6 Continue pushing the contrast between organic and geometric forms by adding an area of small dots, which have an organic feel.

7 Paint in additional areas of opaque color to balance the geometric shapes.

8 Here, I'm adding a light layer of beige translucently over some of my shapes to push them into the background a bit.

9 Bringing in a pop of bright color adds interest and helps to move the eye around the painting.

10 I added emphasis to the yellow triangles by showcasing one with strokes of a neutral color. I echoed the same downward-pointing shape by painting a layer of neutral color around a larger triangle shape above.

11 Try out other geometric shapes, drawing outlines with the fine tip of an acrylic paint marker. While the marks are fresh, use a large brush dipped in water to blur the drawn lines a bit, softening them and blending them into the background.

12 To finish, bring some crisp focus back to some of your earlier shapes, using a brush with a hard straight edge and black paint. This is a great way to pop the top layer.

Susan Nethercote

Our friend Susan is a painter, clothing designer and creative business consultant, as well as a passionate student in our yearlong e-courses. We asked her how she keeps her creative fire going with all that she does.
—**Faith & Mati**

CULTIVATING CREATIVE GENIUS

On most days, about an hour after lunch, I find myself yawning and lacking energy. Can you relate? I could put it down to having two young children, my habit of rising early, perhaps even my need to quit sugar. My need for a mid afternoon pick-me-up is always there.

I have been a meditator for many years now, and I've long been sold on the benefits of having a regular practice. So, when I realized that my body and spirit needed an energy injection mid afternoon, I sought a way that would meet two needs: body rest and a pep up to my spirit. I developed a practice that seems to fill both needs.

I lay down, plug in my earphones to my iPhone and listen to one of my favorite pieces of relaxation or meditation music (my current favorite is the "I Am Wishes Fulfilled Mediation," which you can buy on iTunes).

I begin allowing myself to feel the feelings that I most want to feel every day: Connection, Flow, Divine Resonance, Joy and Creative Genius. I literally imagine the feeling of these emotions until they are palpable in my body, like I am living them and engraving them on my cellular memory. It feels amazing.

I first got onto meditating on my core desired feelings through Danielle LaPorte's wonderful book *The Desire Map*. Her theory is that all the goals we make and all the striving we do is our attempt to *feel* a particular way. We think that when we achieve a particular goal, we will feel a certain way—successful, loved, free, at peace and so on.

She suggests we should first get clear on how we want to *feel*, then formulate our goals and action taking from those feelings, ensuring that everything we are doing in our lives is in alignment with the feelings we most want to feel every day.

My practice has become my way of injecting a bit of manifesting magic into my afternoon rest/meditation. Sometimes I fall asleep for a few minutes during it, which, while not ideal in traditional meditation, is wonderfully restful. Upon waking, I feel revitalized and refreshed after having allowed my spirit to drift into sleep on a river of beautiful emotions.

A place I have seen results in this practice is in relation to my painting. One of my core desired feelings is Creative Genius. To me, Creative Genius is an energy that feels like an open channel to the creative energy of the universe; energy that wants to flow into me and out of me and wants me to trust and respond to my intuition and instincts from one moment to the next in the art-making process.

When I approach my painting from this space of being in connection with the energy of Creative Genius, it feels like a whole layer of doubt in my ability has been shed like a skin. I feel a connection with that mysterious force that flows through me when I'm in the zone.

Perhaps you might like to give it a try before painting, before writing, before whatever your art may be? Put yourself in the feeling of Creative Genius before you even begin. Play with it and see what happens when you allow yourself to deeply connect to the feeling of Creative Genius.

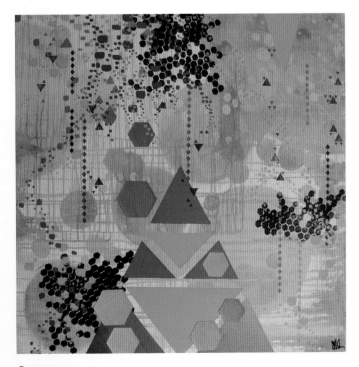

Geoscape
Susan Nethercote

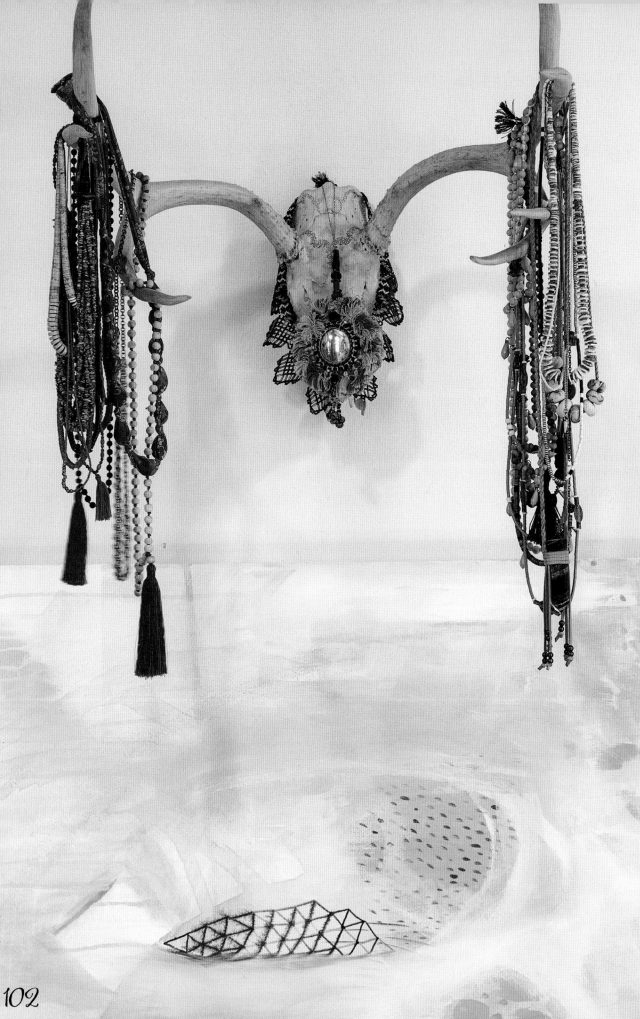

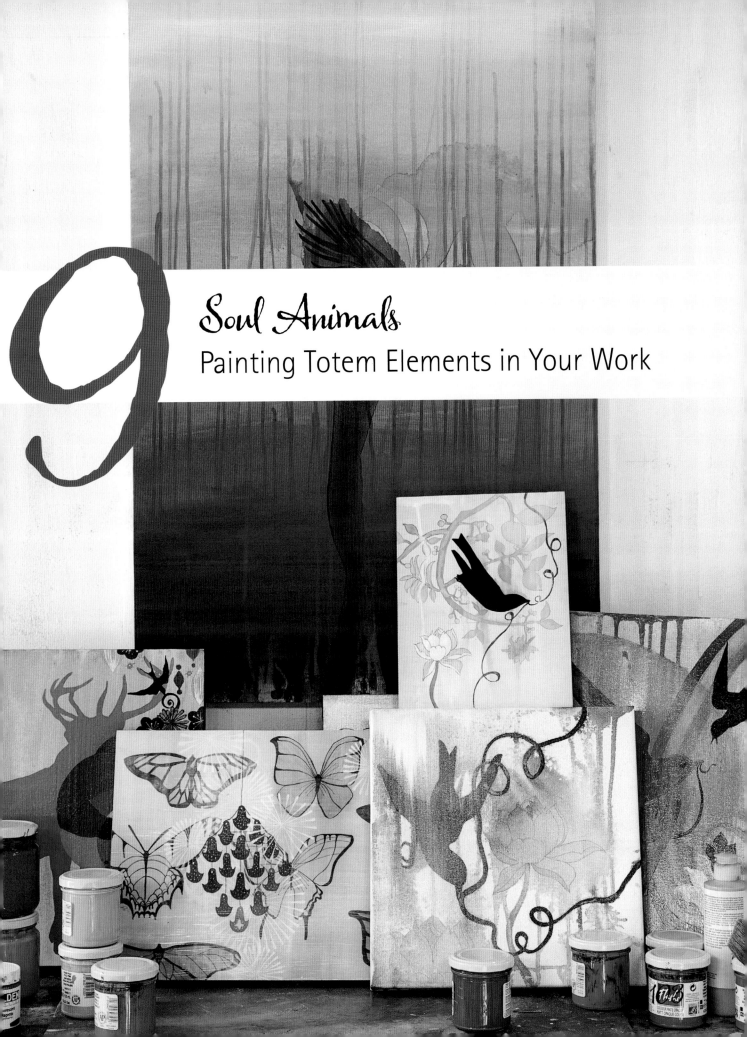

9

Soul Animals
Painting Totem Elements in Your Work

Animals are soulful; this I know to be true. I love elephants in particular and have always felt connected to them. Elephants are viewed as sacred animals in Asia, and the Indian elephant is decorated and worshipped during many festivals.

This morning, I was walking and talking with my friend Kathryn Gilmore, who spent an epic time volunteering at an elephant sanctuary. Here is what she has to share with you:

During my time at the sanctuary in the jungles of Cambodia, I witnessed a small herd of elephants behaving in a way that brought me to tears. There were five elephants, all of whom had retired in the valley after years of tortuous physical labor. One of the most touching interactions was between the self-appointed matriarch and another much older elephant.

The elder elephant was around sixty-five years old, and because she had lived a life of neglect and abuse—her ribs compressed from years of being shackled with ill-fitting harnesses, one of her eyes blinded by a bull hook—she simply did not know how to care for herself. So the younger elephant

I would like to paint the way a bird sings.
—Claude Monet

helped educate her by showing her how to forage, how to drink from the river, how to collect deep red mud from the valley floor and throw it over her back to protect her from the hot sun.

Watching the way in which these elephants cared for each other—the absolute trust and compassion they displayed—made me feel like I was seeing their souls. They broke my heart open and taught me about hope, belonging and family.

We can learn through looking at the animals we are drawn to or feel a kinship with. Maybe your soul animal is one you paint all the time or one you identify with. I've been obsessed with painting elephants for the last ten years. I was wondering why I was so drawn to painting elephants, especially with their trunks up, and did some reading about how they are a strong symbol for luck.

You probably knew that, but maybe you're like me and will be pleasantly surprised to learn that they are also symbols for strength, wisdom, solitude, strong sense of loyalty to the family and intelligence.

Honoring their past, they grieve their fellow elephants by sitting with their passed friend's body for days.

I have a wonderful resource for spirit animals called *Animal Speak: The Spiritual & Magical Powers of Creatures Great & Small* by Ted Andrews. I'm excited to dive in and explore this topic through paint with you.

—Mati

Butterflies (and sometimes dragonflies) have shown up in my work over the years, and through them, I have explored and evolved my voice within my work.

When I researched the meaning of butterflies, I found they are universally honored throughout history for their complicated metamorphosis and as bringers of rebirth, new beginnings, transition, celebration, lightness and the soul.

I revisit butterflies in paintings frequently, and I love how they show up for me in what feels like a continuation of their evolving relationship to my work. They are my soul animal for sure.

I thought it would be fun to create a collage of the different stages that one of my butterfly paintings went through on its way to being done.

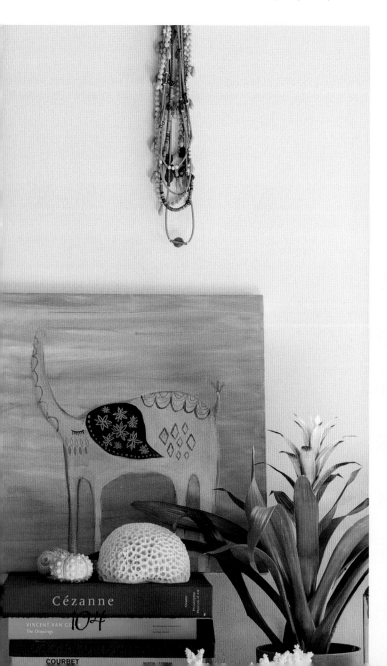

Cézanne

VINCENT VAN G
The Drawings

COURBET

Taking step-by-step pictures of the creation process as I take my pieces through different stages has been a great tool that I encourage you to try. I use the pictures as markers for different phases that most of my paintings seem to go through; they help me remember what to do when I find myself in those familiar places again with new paintings.

While making the painting you see here, I was reminded of three important truths:

1. That every piece goes through a "messy" stage, where I'll feel a bit frustrated with it.

2. Usually this "messy" stage is right before I'm very close to resolving the piece, so this is a time when I need to pay close attention to my instincts and feelings about what needs to happen to resolve the piece. The bottom two pictures in the collage of four photos on this page illustrate this point. In my last step I simply toned down the right side of the painting with some light blue washes and white dots. These simple steps brought me a sense of completion.

3. It's important not to overthink it and listen to impulses that are percolating to the surface of your mind as you work. It is through practice in listening to these impulses that we improve over time!
 —Faith

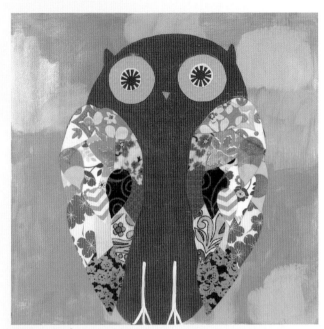

Orange Owl
Mati Rose McDonough

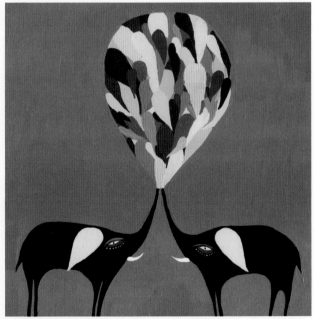

1,000 Languages
Mati Rose McDonough

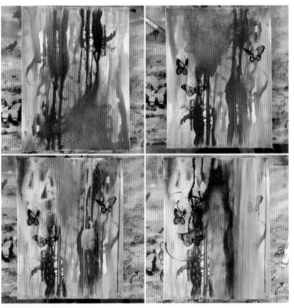

This is an example of documenting the step-by-step creation of a painting.

Painting Your Soul Animal

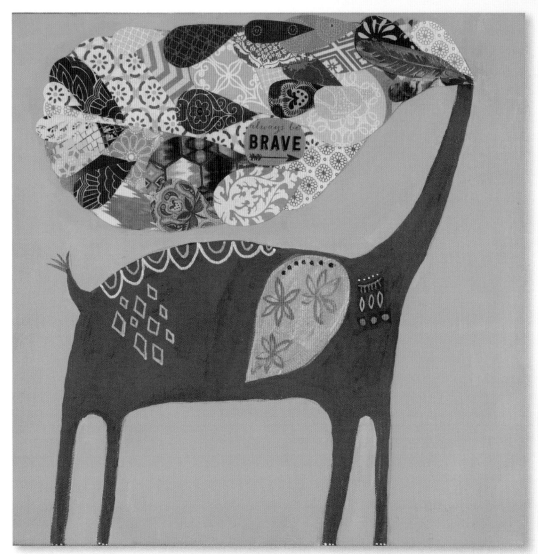

WHAT YOU'LL NEED

- acrylic medium (or Mod Podge)
- acrylic paint
- acrylic paint markers
- canvas
- decorative paper
- gel pens
- paintbrushes, variety of sizes
- palette
- pencil
- scissors

Take a moment to reflect on the animals you are naturally drawn to. Your soul animal can become a representation of your inner being and qualities you admire and want to cultivate. Think about its personality: Is it strong, fast, affectionate? Is it looking at you, or are its eyes closed? Think about characteristics that stand out and keep in mind that you can exaggerate various features, such as my elephant's skinny legs and long upward trunk. Think about how you can play around with shape, color and size of features. It does not need to be realistic, so have fun when designing your soul animal.

For this soul animal painting, feel free to use the elephant as your animal, or choose an animal you connect to personally. You can add adornment through symbols, flowers, plants, words, etc.

Quick Tip

You may wish to combine more than one animal for this painting if more than one seems to speak to you.

106

1 Draw your soul animal with pencil onto canvas. I painted the background first in a lush turquoise.

2 Using a smaller flat brush, paint the interior of your animal. I painted my elephant a charcoal gray.

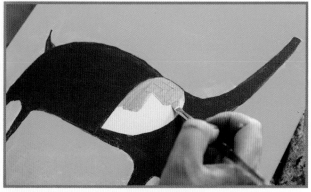

3 Using a small brush and a contrasting color, fill in a portion of your animal such as an ear, beak or tail. Here, I filled in the elephant's ear in gold.

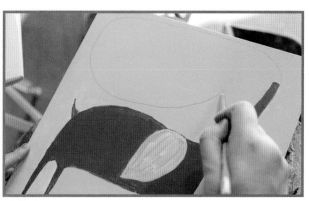

4 It's fun to make a speech bubble coming from the mouth of your animal. I drew my bubble to come out of the elephant's trunk.

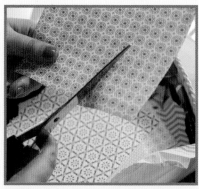

5 Look through your decorative paper collection and pull out some coordinating colors and patterns that complement your paint colors. Cut out teardrop shapes of assorted sizes.

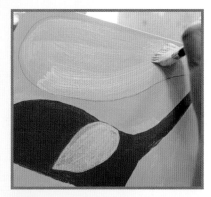

6 Dip a larger brush into acrylic medium and use it to fill in the speech bubble.

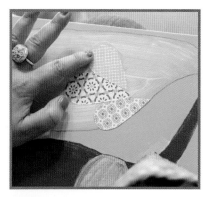

7 Begin placing the shapes into the wet medium. You can experiment with different sizes and shapes (could be triangles, diamonds, circles . . .).

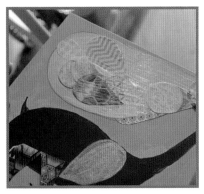 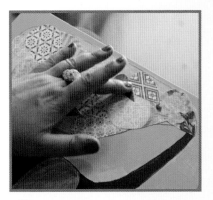 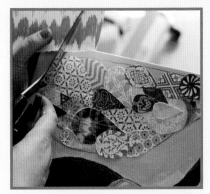

8 After sticking several shapes down, brush over everything with some fresh medium.

9 Continue to place and layer the teardrop shapes. Don't worry too much about how the patterns and colors are playing together.

10 See if there are any holes in your collage and continue layering until the bubble is beautifully filled.

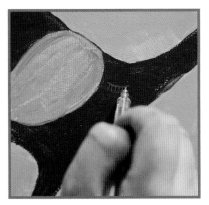 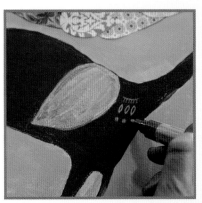 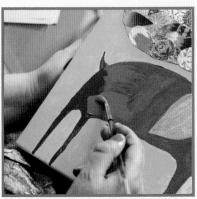

11 Select a contrasting gel pen and begin adding a few details to your animal. Here I'm adding a closed eye and some lashes.

12 Using as many or few paint markers as you desire, continue embellishing your animal. For my elephant, I was inspired by the way the people of India honor the elephant as sacred.

13 Look at your animal and decide if it needs any additional paint. I gave most of the elephant a second coat to ensure the edges were tidy.

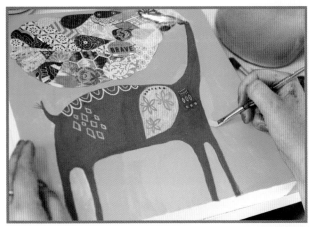 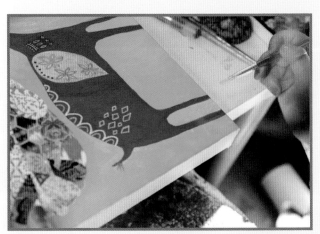

14 I continued to add adornment to the elephant with acrylic markers, creating scallops, geometrics and floral designs from my imagination. I also tightened up the background layer and paid attention to the edges in particular, where the brushstrokes show most.

15 Sometimes it's helpful to rotate the painting to access all the spots most effectively.

To Inspire You
KATHLEEN DAUNHAUER, LOUISE ELIZABETH AND ELKE MAY GLENDENNING

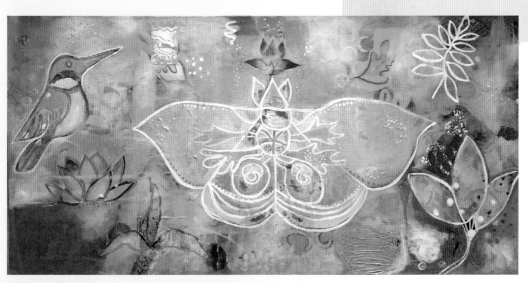

Moth Unfolding
Kathleen Daunhauer
I am influenced by personal iconography, nature and dreams. Events in my life, past and present, are reflected upon and transformed into personal icons and symbols. Animals, insects and birds—what may be called animal totems—appear repeatedly in my paintings. Their message is to communicate concepts from a primordial place inside of me, which my thinking head could never compete with.

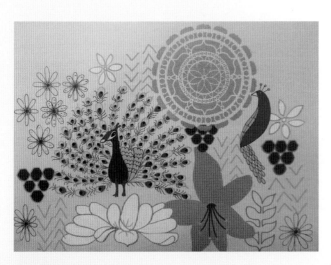

Peacock
Louse Elizabeth
I am influenced mainly by the flora and fauna of the natural world—a sense of walking through joy, beauty, fun and color. I construct patterns of shape and texture, making intuitive choices that create a rhythm of ideas. My work is a secret garden of images, creating a narrative based around a theme. Often this can be a mixture of soul animals and flowers that resonate with me. Birds are one of my favorite soul animals to paint. They represent so much, from quiet stillness to flight and extraordinary moments like the peacock with its feathers outstretched here.

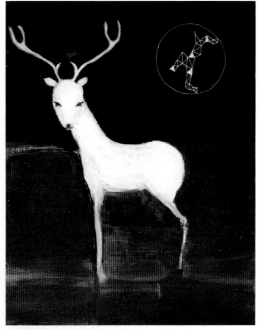

Untitled
Elke May Glendenning
Ninety-nine percent of my paintings are of deer. I've felt a deep kinship with them since childhood. They are gentle souls, very in tune with their surroundings, graceful and magical. To me, they symbolize the connection between the physical realm and the spiritual—a conduit.

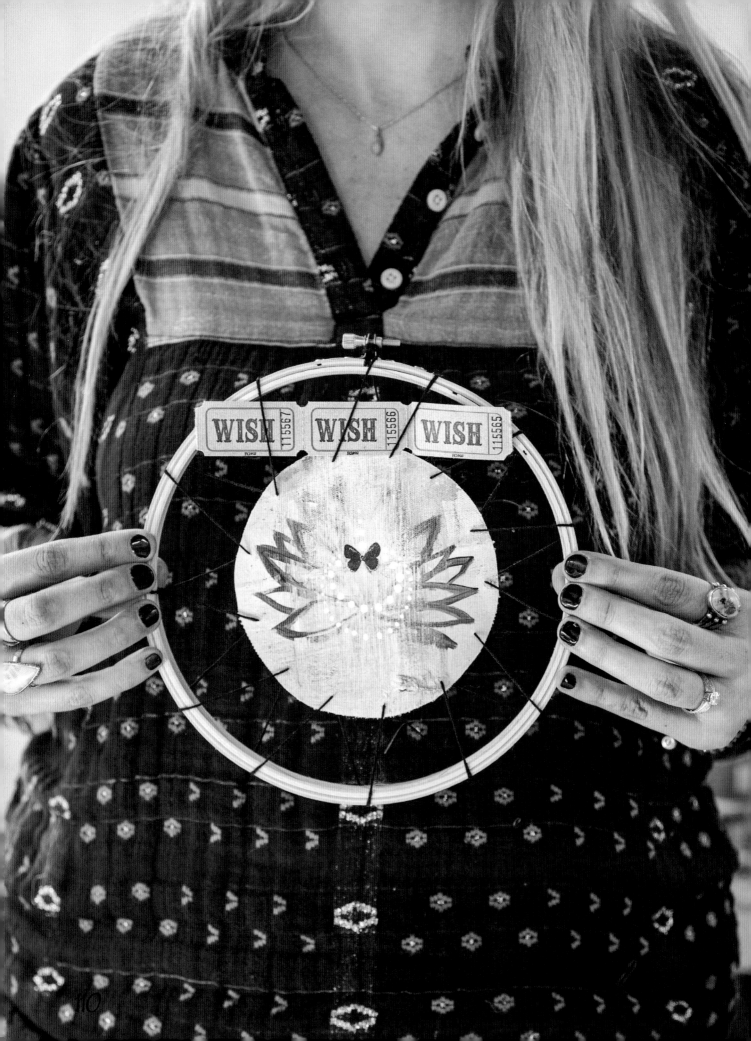

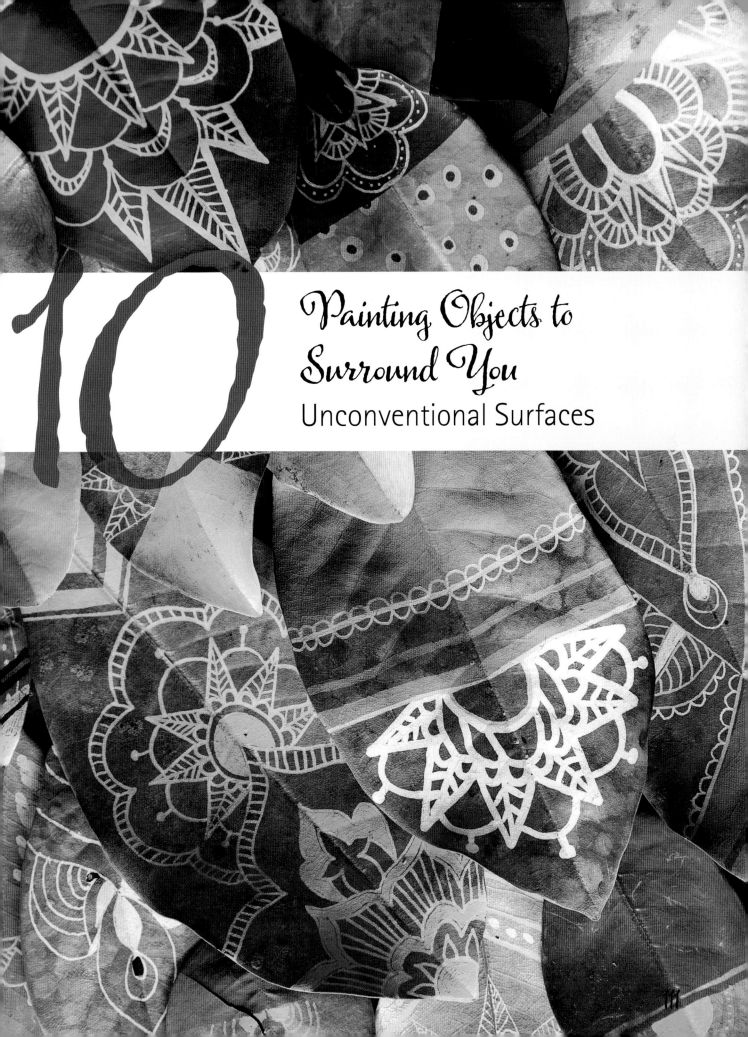

10

Painting Objects to Surround You
Unconventional Surfaces

Back in my early days as a painter, I had fallen so in love with painting that I'd often find myself thinking about all of the many surfaces I could decorate with paint. My college roommate would joke about how she'd come home to find me painting ornate designs all over things in our apartment. I painted our dining room chairs, an old camp trunk, the walls of our hallways, my own clothing. I was captivated with the transformations that I could create through paint.

Over the years I've explored working on so many unconventional surfaces, these days it is often a tool I use when I'm feeling too comfortable in the studio and need to shake up my thought process. Choosing an unconventional surface to paint on is simple; an unconventional surface really only has to be new to YOU. For example, if you've never played with painting on wood panel, just choose that as the support for your next painting instead of canvas. Through making small,

I'm going to make everything around me beautiful—that will be my life.
—**Elsie de Wolfe**

adventurous choices, we strike out in bold ways and often end up surprising ourselves.

Painting leaves is one of those projects that is easy to cycle in and out of, and I have found that setting up a station in my home where I can quickly dive into a simple project like this helps me to more readily incorporate painting into the everyday workings of my home. Through this project, I'd like to invite you, as a part of your painting practice, to think of ways you can dive easily into simple painting or drawing rituals just like this painted leaf project. You don't have to draw on leaves; it could mean drawing in your sketchbook for five minutes while dinner cooks. In those five minutes, you will have spent time dedicated to your internal world, and those explorations build on themselves over time. By creating new rituals with personal meaning, we weave more sacred into our days and our weeks, which turn into our months and years! Begin by thinking of a few things that inspire you that you can turn into small rituals that will become routine habits. I've found that these habits form the basis of not only our painting practices but really our outlook and our lives.

Here are some other ideas for unconventional surfaces that are fun to paint on: round Christmas ornaments, antlers (you can buy naturally shed antlers on Etsy), gathered sticks (driftwood beach sticks are especially fun), pieces of fabric to be stitched together to create a festive garland. The list is really endless. On one of our retreats in Costa Rica, many of our participants collected driftwood sticks on their morning walks, then began painting them in between painting on canvas. It became a joke on the retreat that whenever someone felt stuck in their painting on canvas, they

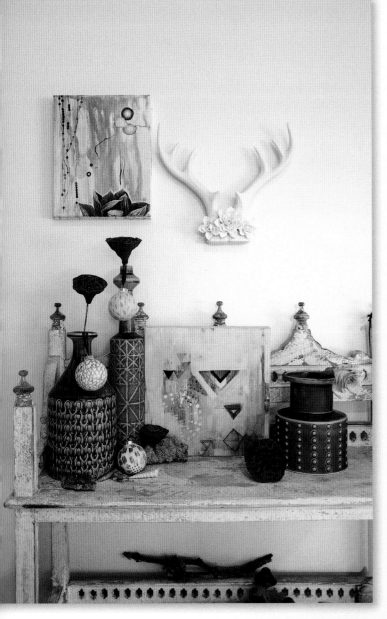

112

needed to take a break and "go paint a stick!"

Especially around the holidays, I like to step out of the studio and create projects I can use around the home to festively decorate, as well as fun projects I can create with my children! I've done all of these projects with them, and they are a great way to easily craft together. The things we make together always end up being the things we bring out year after year.

I hope you have fun with this painted leaf project. This is an exciting project because it is another way to dive back into the mandala drawing work that I introduced in the Painting Mandalas lesson in chapter 6. Through using various mandala forms and drawings in an abstracted way, we see how much variation we can achieve through repeating the same forms. This project can also be a great way to loosen up before more "serious" painting, and I find that the doodles I do on the leaves definitely inform my paintings on every other surface!

Each time I do this project, it gives me the chance to explore the sacred within me by connecting to Mother Nature through the gathering of leaves in my yard and also through the sacredness found in the mindfulness of taking time to sit with myself and simply paint. Taking this time helps me connect with myself and my goals on a deeper level, as well as celebrate the sacredness that is woven within the fabric of every day.

—Faith

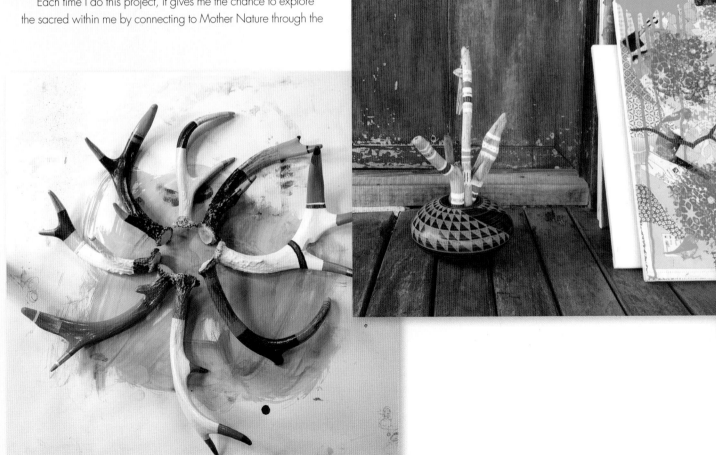

Painting on Leaves

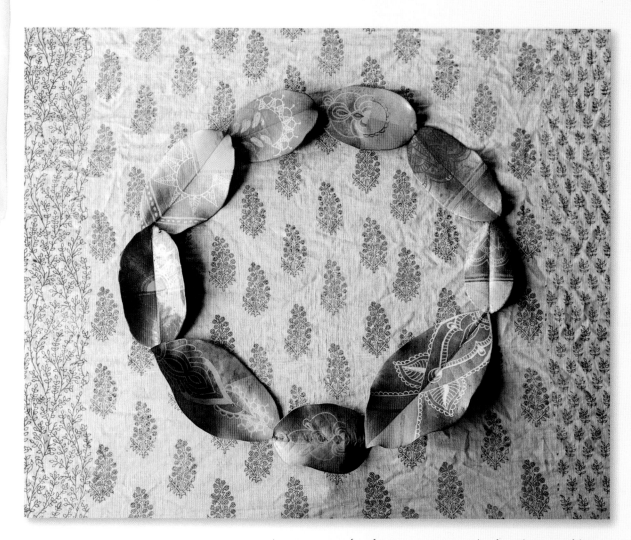

WHAT YOU'LL NEED

acrylic paint markers, various-sized tips
gathered leaves

Leaves are one of my favorite unconventional surfaces because of their accessibility; just walk outside and there are usually a few right there on the ground. This is a fun project to do in autumn, and it is a project you can do with the whole family, as it translates well for all ages. I've done similar paintings on rocks and antlers, but I always come back to leaves for their versatility and availability.

Quick Tip

You can display your painted leaves together, taped to a wall, using washi tape, or you can use string or ribbon to tie the leaves onto branches that can be placed in a vase for whimsical table decorating.

1 In this demo, I am using magnolia leaves, but any broad leaves with a relatively flat surface will work well. Choosing some bright-colored paint markers, I paint approximately half of each leaf. This is best done with a wide-tip marker to quickly cover the most surface area.

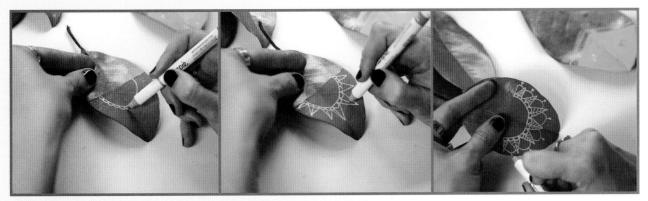

2 Once these large areas of color have dried, begin drawing intricate designs onto the leaves. Start by drawing on the painted half of the leaf using a light-colored thin-tip paint marker. Starting with a half-circle shape creates a base from which you can build a mandala, repeating simple geometric shapes and forms in each layer as they radiate out from the half circle.

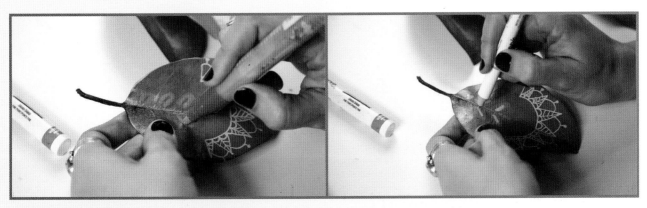

3 Add a few simple shapes on the unpainted half of the leaf, filling those in with one of the colors you used on the mandala half to create visual unity in the piece.

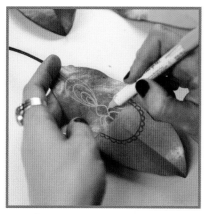 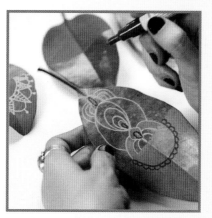 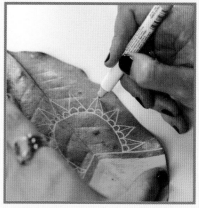

4 Begin the next leaf with another half circle. Then try painting with a light color on the unpainted half of the leaf, using loops and ovals that connect to each other.

5 Add some details to those shapes by filling in a few of them with the same colors you used on the painted half of the leaf.

6 Draw on a new leaf with the same circle mandala forms used on the first leaf. Build all of your other shapes around the circular form.

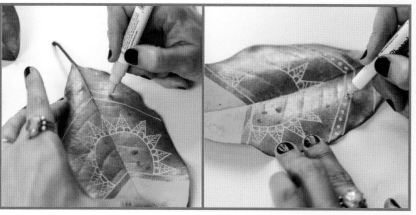 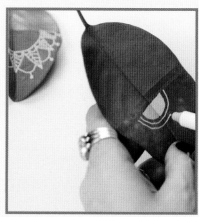

7 Here, I finished this design with bold yellow lines echoing the triangular edges of the turquoise-painted half of the leaf.

8 Begin the last leaf with a variation on the half circle, filling it in with color and adding a few other echo circles.

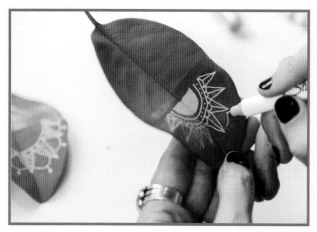 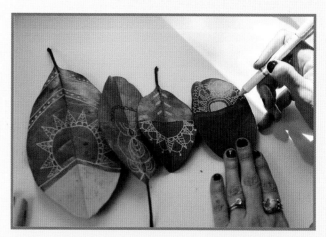

9 Complete the design by playing with the same mandala forms radiating out from the center half circles.

10 Repeating similar forms and colors throughout all of the leaves creates a unity between them that makes them work well together as a group.

To Inspire You

NIKKI CADE, KELLY CLARK AND AMY KOMAR

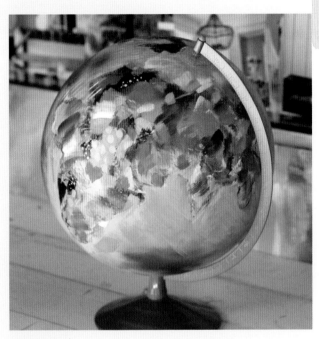

Wanderlust
Nikki Cade
I started painting globes as a way to channel my desire to travel. I didn't realize my art would provide such a wonderful opportunity to meet people all over the world, but I'm so glad it does!

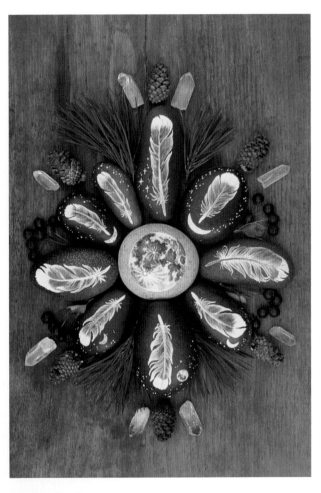

Tool Kit Wrench | Found in Alaska
Amy Komar
My husband and I have always enjoyed "junking," and over the years, we have acquired a large collection of rusty artifacts. At my husband's insistence, I first began painting on some vintage mining implements. Intrigued with their patina and the nuanced intricacy of their shape, these artifacts have become a type of canvas for me, challenging me not only to preserve their historical context, but also to present them in a totally new perspective.

Small Collections
Kelly Clark
After years of painting large scale, I began to yearn for the intimacy of art small enough to be held in my hand: quiet messages and reminders intended for touch, for carrying in pockets, for placing in direct lines of sight. Painting stones became a sort of holy meditation for me, from the hours spent combing beaches and riverbanks for the perfect stone, to the monochromatic colors, to the use (and further building) of my own visual vocabulary. The repetition of painting similar images again and again became akin to prayer beads: Each stone is a chant in a long string of whispered words. I come back to stone painting whenever I need to reconnect to myself, my inner sight and the meditative side of art making.

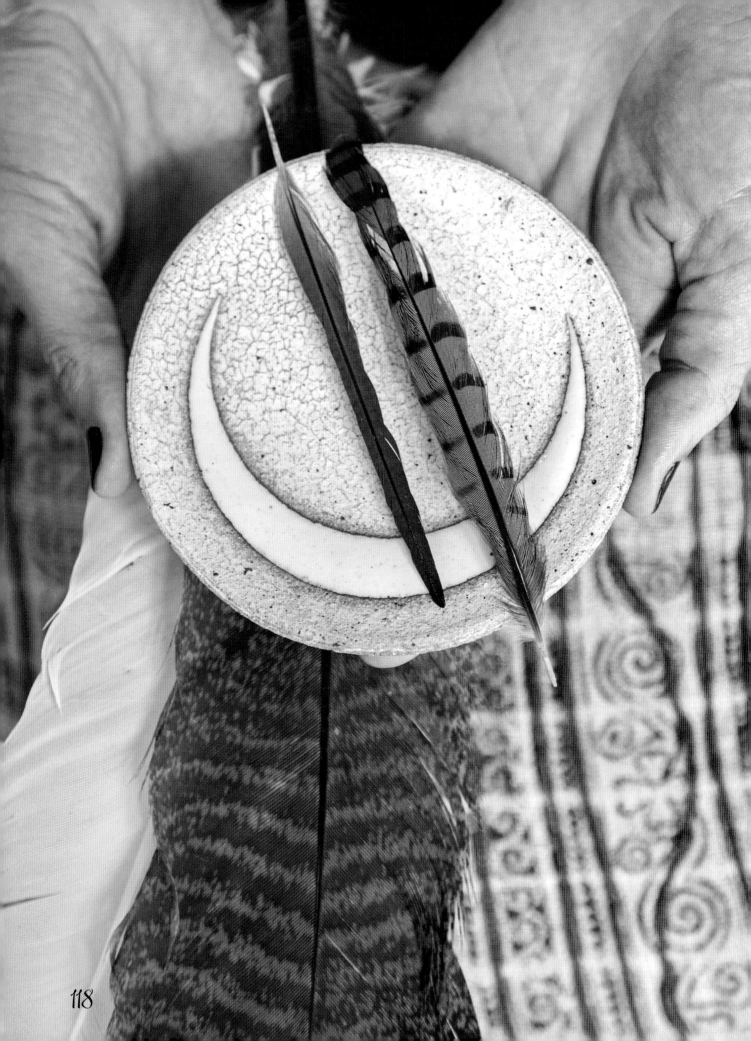

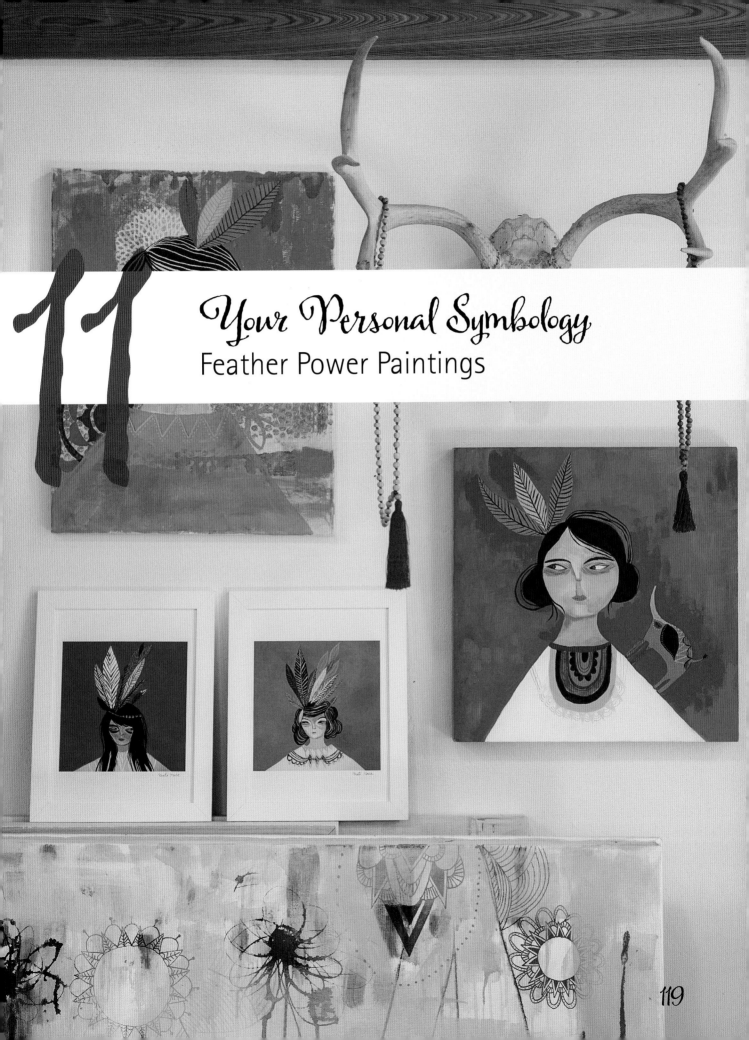

11 *Your Personal Symbology*
Feather Power Paintings

Faith and I both love adornment. We actually first got to know each other virtually with the Instagram hashtag #dailyadornment. (Feel free to add to it!) It's fun to think about what adornment you like to wear, be it real or imagined. Adornment in the form of feathers, flowers and made-up jewelry is a fun element to think about when it comes to creating your Feather Power painting.

It's time to really go inward with yourself. I'm going to share with you a peek into how I come up with my ideas for my Feather Power paintings. My process is relatable to all paintings; some of the preliminary steps I take before diving into the act of painting. I want to show you the behind-the-scenes process of idea generation that can imbue each of your paintings with meaning.

I free-wrote and doodled the answers myself, and I suggest you give this hands-on exercise a try in your sketchbook as well.

This helps remind me of what elements I like to bring into my art and what I personally am inspired by. This is an important step for us as artists in getting to know our distinct influences and what makes our art our own!

With this picture of myself in mind, I did a sketch from my imagination tying some of these elements together.

Have fun with this gathering process! Use these prompts to create your own painted empowered ladies, or go off course into what fuels you.

—Mati

Let's dive deep into the creative process of digging for inspiration to create personal iconography. I have a gorgeous statement necklace that inspires me endlessly. At one point, I wanted to incorporate it into a painting, so I looked at it while drawing it and abstracted the sketch into simpler shapes. Look at your inspirations around your home—pillows, textiles, rugs, clothes, photos, jewelry. . . . What is calling your name? What colors, patterns, shapes, imagery and textures do you love?

After capturing the simple shapes of my necklace, I did some digging within myself with some key questions related to my Feather Power women, and I'd love for you to answer these for yourself as well.

Who are my role models? What qualities of theirs do I want to embody (and therefore my personal icon)? Is there more about how each of them looks that makes them quirky or unique? What messages do they want to convey? What styles do I get inspired by? What styles or design elements influence me greatly?

feather power sketching:

based on statement necklace

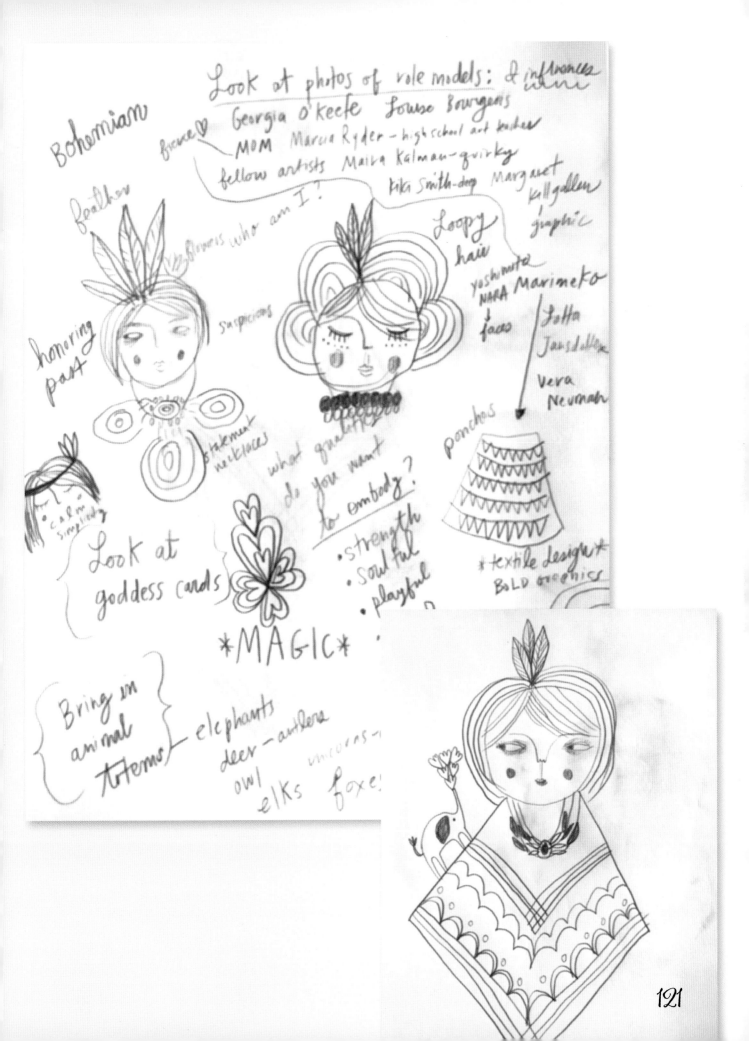

Feather Power Painting

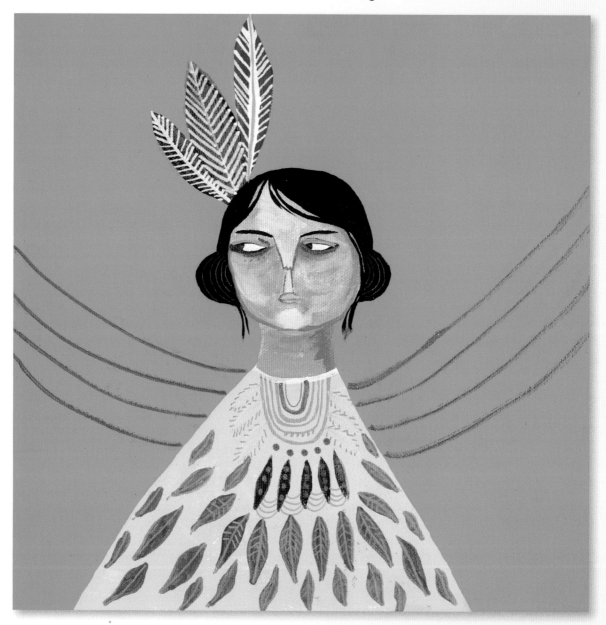

WHAT YOU'LL NEED

acrylic paint, colors you like

acrylic paint markers

canvas

paintbrushes, various sizes

pencil

water

Your Feather Power painting will represent the way you would like to feel empowered. It is like a self-portrait of your goddess-self, similar to the soul animals in chapter 9. It's a chance for dressing up, exaggerating elements you are drawn to, while combining fantastical qualities like mermaid tails and crowns and all kinds of beauty. Think about how you want to feel in the world: Peaceful? Powerful? Playful? How can you show that through your portrait? You can also include animals and other totems to make her extra magical.

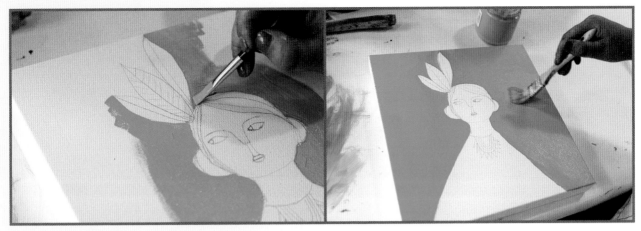

1 Begin by creating the sketch of your figure directly on the canvas in pencil. This doesn't need to be elaborate. A simple triangular shape works nicely for the body, and because it's a poncho, you don't even need to worry about arms.

Select a color and paint in the background. For my background, I chose Viridian Green. Use a small brush to define the edges of the figure. Then it's easier to make larger swaths with a bigger brush to fill in the entire background.

2 For switching back and forth frequently between brush sizes, it's helpful to have a large container of water nearby for rinsing and resting your brushes as you switch between them.

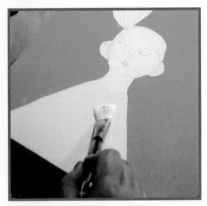

3 Select a lighter contrasting color and fill in the edges of the poncho with a smaller brush. Then, like with the background, fill in the interior of the poncho with a larger brush.

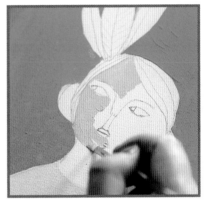

4 Select a base color for the face (I like a golden shade) and fill in the face area with a small brush.

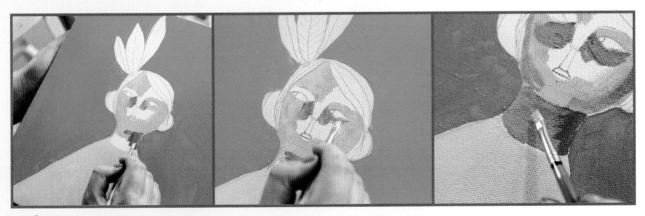

5 Create shadows on the face and neck using a slightly darker shade. I like to add a bit of shading under the chin, under the eyes (a great way to emphasize them) and at the side of the nose. Here, I mixed an in-between color using the base and the shadow colors to fill in the rest of the neck.

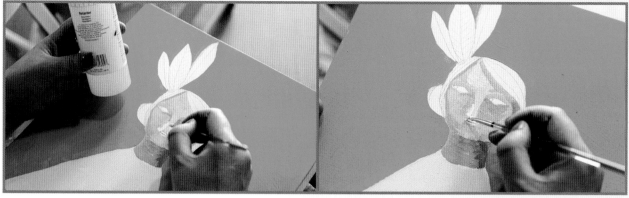

6 When working on areas such as a face, it's nice to be able to take your time mixing or blending colors directly on the canvas. Using a bit of Golden brand retarder on your paint palette makes the acrylic paint act more like oil paint and frees you up from feeling rushed.

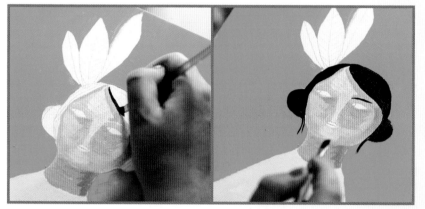

7 With a small flat brush, begin on the hair. Fill in the hair area completely. Consider long, flowing hair, one or two braids or, as I did here, hair inspired by Princess Leia. Also use fine, simple lines for eyebrows.

8 I sometimes like to take my painting to a chair without a table or easel. Also, all my adornments help inspire me in decorating her.

9 Now onto the feathers! Alternate between two colors. I chose blue and pink.

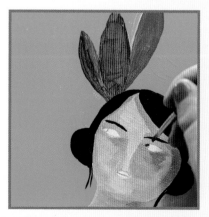

10 Decide where you want your woman to be looking. I wanted mine to be looking sideways suspiciously (as noted in my personal inquiry earlier), so using a small brush, I placed pupils at the corners of the eyes.

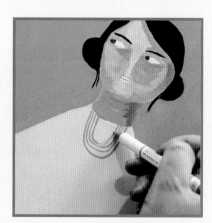

11 Draw in adornment using a fine-tip paint marker.

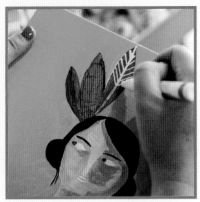

12 With a similar-sized paint marker, draw the shaft of the feathers. You can do this with a small brush if you like. Continue drawing the lines of the feathers with the paint maker. I love the detailed repetitive aspect of creating the feathers!

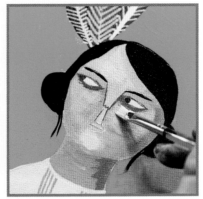

13 Decide if your woman needs any highlighting in a slightly lighter color around the edge of her face. Here, I'm adding a lighter color where the face is wide, flat and reflective— cheeks, forehead and chin.

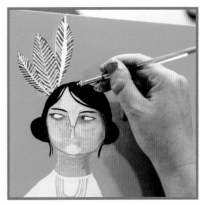

14 Painting in the hair tendrils adds a nice fine detail.

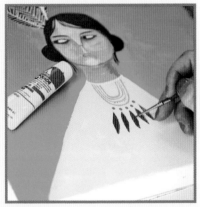

15 Create her statement necklace using a brush and paint or paint markers. I used Acryla Gouache (a gouache/acrylic blend) in Luminous Red. I love this line of paint for its colors, and it's really great for detail work.

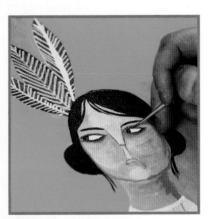

16 You may want to do what I did and repeat a color—for me, red—from your necklace as a detail around the eyes.

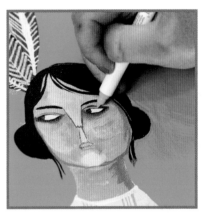

17 A turquoise paint marker works nicely to add more eye makeup.

18 Finally, decide if you need to tighten up the background or touch up any final areas.

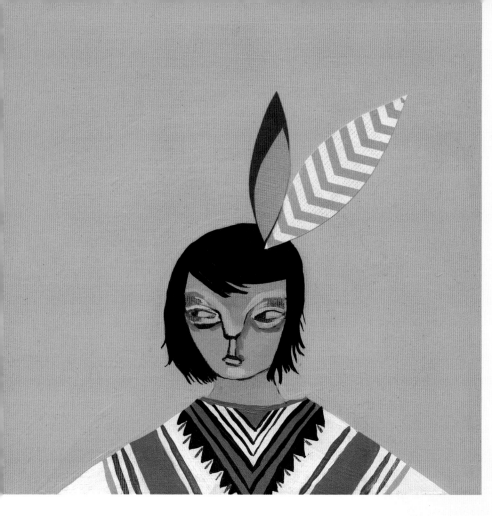

Feather Power Ochre
Mati Rose McDonough

Feather Power Rose
Mati Rose McDonough

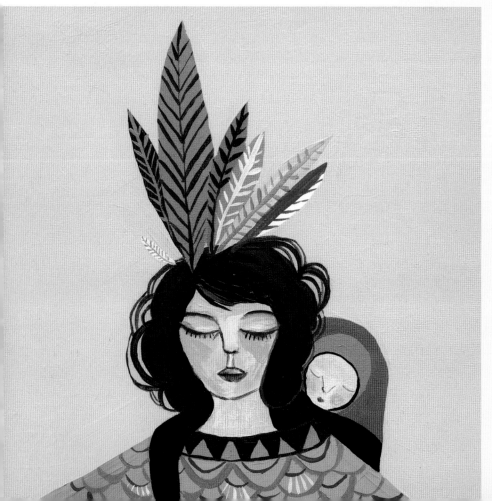

To Inspire You

LISA FERRANTE, ECO SHUMAKER AND LILY UOKA

Lisa, Eco and Lily were students in our e-course and retreats.

—Faith & Mati

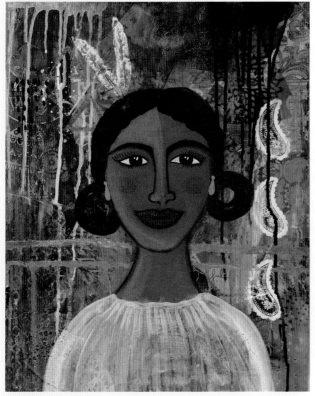

Costa Rica Chica
Lily Uoka

Made during Mati and Faith's 2016 art retreat in Nosora, Costa Rica. I've always had a deep appreciation for, and found comfort in, nature. Hence, I thoughtfully used images of tropical plants, flowers, waterfalls and spiritual designs for the first layer of collage. I even used a leaf found on the ground while collecting foliage for our nature mandala exercise as a stamp for the two white feathers in her hair.

The brave, calm look in her eyes, subtle smile and quirky hair show her rounded, eclectic personality. She is prepared for an adventure and in tune with her nature surroundings.

Wonder
Eco Shumaker

I grew up in Las Vegas, where we spent most of our time in the swimming pool. My sister and I pretended to be mermaids. As an adult, one of my first painting series was called "Mermaid Frenzy." I paint mermaids because they remind me of a very simple time when things were innocent and easy. I think the images of the mermaid help me process the past. The pensive look on my girls' faces are sometimes interpreted by others as sad, but for me they are in deep introspective thought.

Truth Seeker
Lisa Ferrante

My creation process for this piece was so different from what I usually do. Faith and Mati's class really brought me out of my head and into a much more instinctual space. The freedom of pouring paint and making marks really allowed her to come from a very primal place and to evolve as I was exploring a whole new style. I call her *Truth Seeker* because that is who I am at my core, and I think she embodies that beautifully.

127

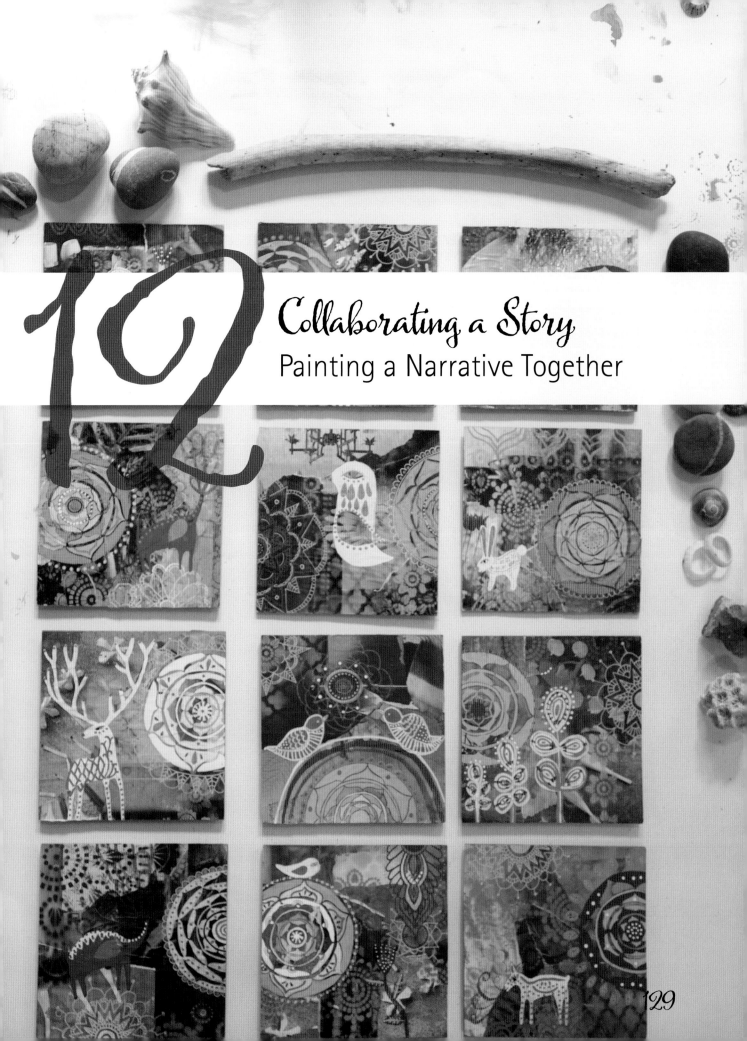

12

Collaborating a Story
Painting a Narrative Together

The longer we paint, the more we realize the importance of the "silent work" that goes into getting ready to paint. Those times involve the work of processing and thinking, absorbing information, gathering inspiration and settling ourselves down to work. Every piece of this process is just as important as painting itself, and when we remain open, we relax further into opening ourselves up to this silent work.

Bringing narrative into your paintings means you are telling your story through your artwork. This is simpler than it sounds and happens very organically over time. As you create many paintings, you will start to find common threads that run throughout your work. These marks and images become the voice that says that something has been made by you. Over time these marks and ways of working become a part of what people call your painting style, so when someone looks at a painting, they can sometimes say it is yours without even knowing!

By documenting this unique mix of marks and images, you will begin to build your personal encyclopedia of mark making—a fantastic reference tool for times when inspiration feels dry and you need a quick visual feast of your own making. Building your own vocabulary of mark making can be as quick as sitting down in front of a few of your own paintings with your sketchbook for an hour or two and sketching the images, shapes and marks that appear most often in your work.

These little sketches are what I came up with by taking visual notes on what I was seeing in my body of work. Through this process of looking, I was able to distill not only repeated geometric forms but also botanical themes shining through the work, especially an old favorite, the lotus flower. By taking this time to look I was inspired to head in unexpected directions, spending more time experimenting with combining my own botanical and geometric imagery in new ways.

> # Find something you're passionate about and keep tremendously interested in it.
> **—Julia Child**

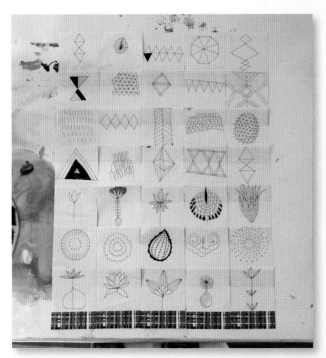

As you make your art, you are giving voice to things that become a visual language. When we can find ways to get at this more easily, it allows us to speak this language with more fluency.

In thinking of putting your work out into the world with a strong voice as well as bringing consistency into the whole body of work, these simple tricks can be an aha moment! We know that as you explore your own voice in your work, it can sometimes feel like you're navigating in the dark, so we think that the more light posts we can put up, the better!

The images in your personal vocabulary may change and grow over time as their meanings to you change. As with anything in life, it's important to allow yourself room to grow, and that is why we like to call this an "encyclopedia" of personal marks, because it can be seemingly endless as you compile them over a lifetime.

Another fun way to develop your voice in your work is through journaling, using quick prompts to get yourself writing.

When we talk about narrative painting, we are really thinking about what makes your work yours. Sit with this thought and write or draw anything that comes to mind. You can start with this sentence: "I believe . . ." Answer this question with whatever comes at the moment. Each time you answer this question, something different might come up.

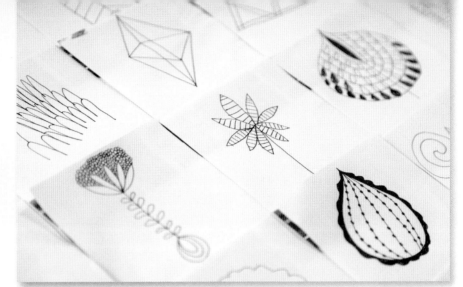

Tapping into your memories can be another great way to dig deep and feel into what makes your work yours. Sit and write or draw whatever comes to mind when you complete this sentence: "This I know to be true: . . ."

Working in collaboration with another artist can be an exciting way to stretch yourself. The two of us know a whole lot about collaboration; one of the things we realized early on in our friendship is that we both shine when working collaboratively. Not only have we written this book collaboratively, but we also collaborate on organizing and teaching our international art retreats together. Since travel and art are two of our favorite things, it felt very natural to develop those loves into teaching painting to groups of women abroad. So far we've held retreats in Costa Rica, Morocco and at home in the United States, and we always have our heads together planning our next painting adventure.

There is an excitement that we both feel as we're collaborating and both of us have ideas that flow, feeding off of each other and growing into something bigger than they would have been on their own.

Working with a friend adds a bit of spice and energy that wouldn't be there if you were working alone!

—Faith & Mati

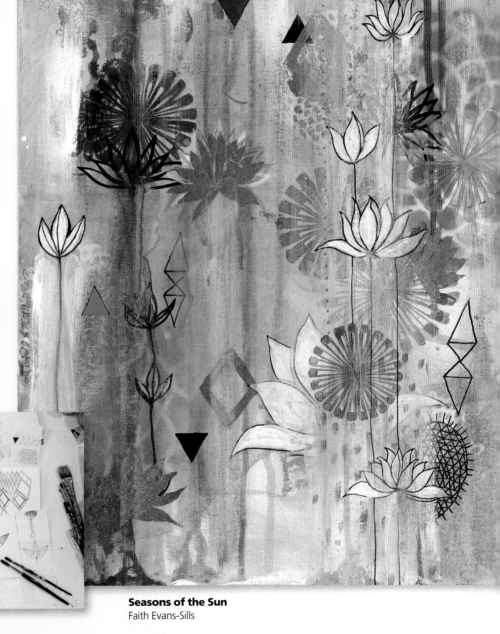

Seasons of the Sun
Faith Evans-Sills

131

Collaborative Painting

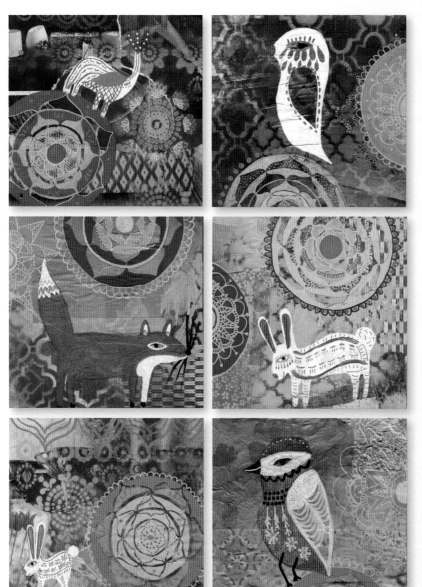

WHAT YOU'LL NEED

acrylic medium (or Mod Podge)

acrylic paint markers, variety of colors

canvases or wooden boards, small, 4–6

collage materials, variety of images and symbols that speak to you

creative friend to collaborate with

pencil

personal encyclopedia of shapes and marks

spray paints

stencils, variety of shapes

transfer paper

Possibly our favorite collaborative project has been an ongoing series of small paintings that we call our Mandala Animalitos series. We began creating these small pieces as gifts for the women who came on our retreats. The project is so much fun that we always seem to have a series of them in various stages of completion that we are sending back and forth to each other in the mail, as each of us adds a layer. When we first envisioned this project, our idea was to take images from each of our "personal vocabulary of marks," images that we have become known for in our work, and each add these images into the paintings that become stronger for having each of our voices combined in them.

1 Divide the canvases between you and begin your pieces with a whimsical layer of collage as a foundation that you can build the rest of the paintings on. Brush a thin layer of acrylic medium onto your canvases and adhere a variety of collage papers.

2 Add a layer of spray paint (work in a space with good ventilation), using whatever stencils speak to you. Consider alternating the canvases you and your friend work on to keep things collaborative.

3 Once the stencil layer is dry, look through your encyclopedia of marks and shapes and using a piece of transfer paper (carbon-side down) and a pencil, transfer the marks or shapes to the canvases. Faith chose this mandala drawing.

4 With your drawing(s) transferred to the paintings, use paint markers to fill the marks with color.

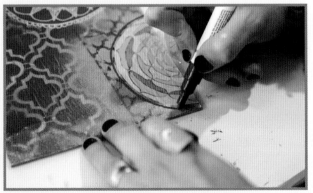

5 Continue adding interest and definition to your transferred marks.

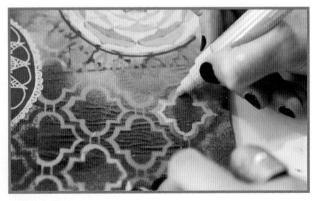

6 Still working on the same pieces, add a second icon, either freehand or as another transfer, and color it with paint markers as well. It's also fun to define some of the stencil shapes. Decide what else your paintings need to finish off this first layer of the collaborative pieces.

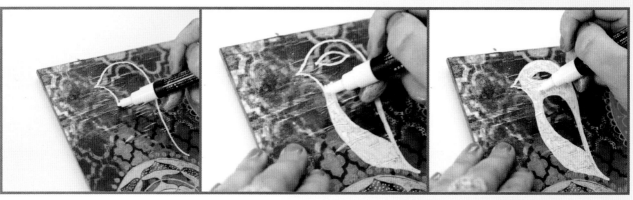

7 Exchange pieces with your friend and create a new layer with your own voice to each canvas. Here is what Mati did with the pieces Faith started. Mati starts by sketching in one of the animals that is a part of her personal encyclopedia of marks. Then she defines the drawn outline using a white paint marker. She adds details to the eye and wing shapes before filling in the bird's body with paint, layering two coats of the white paint to make the bird's body more opaque.

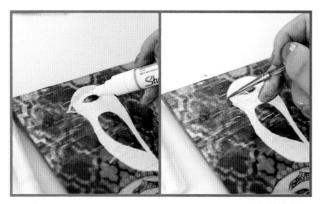

8 Using a very bright paint color, Mati gives the bird a beak. Consider what colors or elements you can echo from what your friend put down in the first layer. This bright coral color echoes some of the colors in Faith's mandalas in the first layers.

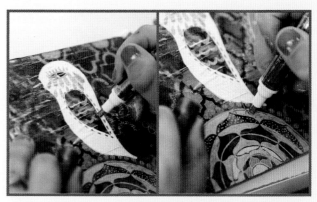

9 Next, using a fine-tip gold paint marker, Mati adds details to the bird's eye. With a few more gold details, Mati finishes off her animal.

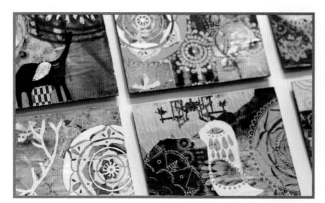

10 In each painting, Mati adds a different detailed animal, combining them with Faith's intricate mandala forms, to complete this series of Mandala Animalitos collaborative paintings!

Carrie Schmitt

HOW TO BECOME AN INTUITIVE ARTIST

You wake up one day and want to be an artist. You wish you could go back to school and study art.

You wonder, *Is it too late to start again?*

You discover talented self-taught artists online who are living boldly on their terms.

You want to do that.

You discover intuitive painting, which is about freeing the creativity within.

You put paint to canvas. Timidly. You try to embrace the qualities of intuitive painting—not to judge what is happening on the canvas, not to have self-doubt—to trust the process, to let go of inhibition and restraint.

You judge what is happening on the canvas.

You doubt everything you are doing.

You think this process is for special artsy types with spiky purple hair, tattoos and combat boots.

You don't know how to let go. You've been holding on to so much for so long.

You keep painting anyway. You stumble through the beginner's shaky right of passage. The rough patches. The unsophisticated muck. You scratch the surface of what might be possible with time.

You sense the wild within you, but it is stuck. You start to remember this long-ago-silenced self. You wonder how to get this out of you.

You get frustrated.

You keep going.

You have so much to unlearn.

You unlearn "I am not creative."

You unlearn "Only a few special people are artists."

You unlearn "I am not good enough."

You learn to trust.

Trusting yourself means believing in yourself, means loving yourself, means caring for yourself, means your world just flipped upside down.

Because caring for your whole self—mind, body and spirit—becomes essential. You are a sacred vessel from which creativity flows.

You are sacred.

You create. Over and over. Diving deeper, your heart swells. There are sensations of light, fire, bursting, shifting, cracking, floating, flowing.

You paint what has never existed before.

You awaken parts of you that never existed before.

Our friend Carrie is an artist and author who contributed this inspiring piece to our e-course and we felt we needed to share it with the world.

—Faith & Mati

Your intuition grows stronger.

The wild in you begins to emerge. You are coming home to yourself.

You feel your power.

You let go.

You unfold. You let things out. You reclaim the parts of yourself that you love. You forgive the ones that you don't. You thank them for what they have taught and toss them out with the paint water.

You let the lines blur.

You let the paint guide you.

You let go.

You finish the painting.

You let go.

You start again.

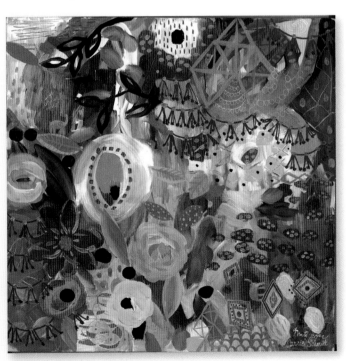

Collaborative Painting
Carrie and Mati

Conclusion

Dear beautiful painters,

As we come to the end of *Painting the Sacred Within*, we want to celebrate YOU! All of your openness, your willingness to take risks, to learn, your bravery as you step out into sharing your work with others. Most of all we want to applaud your dedication and commitment to growing your art, to allowing your muse and new ideas the time and space in which to be fertilized and grow strong under your care. You are spreaders of light through your work. We are your biggest fans, cheering you on as you go. The beauty that we have created together here will stay with us always. As you go forward, remember to keep your eyes open, keep watching, because whatever you see can inspire you in new directions of creativity. Finally, we encourage you to continually send out beacons of authentic light into the world through the voice that calls out loud and clear in your heart. There is no other voice like your own, and when you send your unique call out into the world, you will draw others back to you, your tribe will draw in around you. Deep calls to deep.

With wishes for so many abundant blessings,
Xo, Faith & Mati

Share your voice with us! When you share your work from this book online and on social media, use the hashtag **#paintingthesacredwithin** so we can celebrate you and your beautiful work!

Do you have the courage? Do you have the courage to bring forth this work? The treasures that are hidden inside you are hoping you will say yes.
– Elizabeth Gilbert

137

Mandala template, chapter
6—make two copies

Index

Dedication

We dedicate this book to our fathers, John Duncan Evans III and Brian Dennis McDonough, who soar on every gust of wind brushing our faces and the crest of every white-tipped wave.

You left us too soon, but your voices continue to shine brightly through us in all that we do.

Thank you for giving us eyes that gather inspiration so readily and the wings on which to boldly pursue our creativity.

With Thanks . . .

FROM BOTH OF US:

In the writing of this book, there were so many helpers who we'd like to thank for coming alongside us, giving us support in the process.

We'd like to thank our editor Tonia Jenny for your encouragement and support of our creative vision!

With endless thanks to our talented photographer Julia Lynn (www.julialynn.com), you translated our thoughts and captured our images so beautifully through your lens. The process was so much fun with you on our team!

Thank you, Lauran Weinmann, for helping us wordsmith! We are so grateful for you. Pura vida!

FROM FAITH:

I'd like to offer deep gratitude to my mother, Nell, and my brother, John, for your unconditional love. For the support of my amazing husband, Frank, whose care, endless words of insight and strong foundation of love give me strength to go out into the world and create. You are the earth beneath my feet. To my three beautiful children, Jasper, Carys and Griffin, your energy, inquisitive nature and open hearts inspire me every day to continue to pursue my joy so one day you will know how to pursue your own!

FROM MATI:

Thank you to my roots—my mom, Michael, Jesse and Andrew who helped shape who I am today.

Thank you to my wings—my artist tribe who are dear and inspire me endlessly. Especially my daily walking and talking musician bestie, Monica Pasqual, for hashing it all out. And thank you to my Teahouse Art Studiomates and assistants over the last few years, who have become dear friends, too—Heidi TenPas and Lily Uoka, who have offered me so much support in making it all happen.

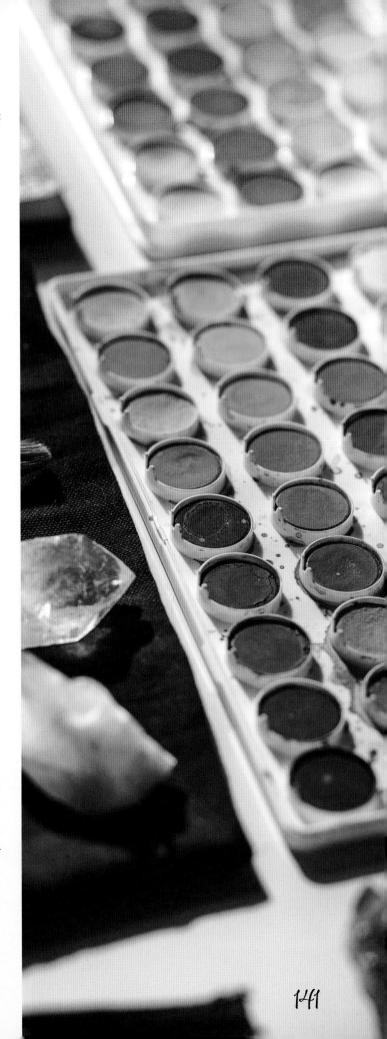

And finally, our deepest thanks go out to all of our past and present students—without you none of this would have been possible—and to the creative women who allowed us to share their inspiring work with you through these pages. Some are students of ours, some are friends, and some are students who have become friends! All of them share one beautiful connected thread: that the bonds of creativity have brought us together into a tribe that holds, inspires and supports us all.

Nikki Cade — nikkicadestudio.com
Kelly Clark — umberdove.com
Suzie Cumming — suzielou.co.uk
Kathleen Daunhauer — kathleendaunhauerart.weebly.com
Annamieka Hopps Davidson — annamieka.com
Louise Elizabeth — cargocollective.com/louiseelizabeth
Lisa Ferrante — lisaferrante.com
Kathryn Gilmore — onwardvoyage.com
Elke May Glendenning — elkemay.typepad.com
Janelle Gurchinoff — spiritcatart.com
Laura Horn — laurahornart.com
Jo Klima — thedarlingtree.com
Amy Komar — amykomar.com
Susan Nethercote — susannethercote.com
Stephanie Perkinson — stephanieperkinson.com
Andrea Scher — superherolife.com
Carrie Schmitt — carrieschmittdesign.com
Eco Shumaker — indigoarthouse.com
Susa Talan — susatalan.com
Lily Uoka — lilyuoka.com
Mary Wangerin — theturquoisepaintbrush.blogspot.com

To continue your *Painting the Sacred Within* journey, visit our websites where we offer video painting lessons, Q&A chats and deep-dive instructions for the topics in this book to take your painting practice even further.

matirose.com and faithevanssills.com

Use our social media hashtag #paintingthesacredwithin whenever you share your art from this book online so we can find and celebrate you!

a content + ecommerce company

Other fine North Light Books are available from your favorite bookstore, art supply store or online supplier. Visit our website at fwmedia.com.

21 20 19 18 17 5 4 3 2 1

DISTRIBUTED IN CANADA BY FRASER DIRECT
100 Armstrong Avenue
Georgetown, ON, Canada L7G 5S4
Tel: (905) 877-4411

DISTRIBUTED IN THE U.K. AND EUROPE
BY F&W MEDIA INTERNATIONAL LTD
Pynes Hill Court, Pynes Hill, Rydon Lane, Exeter, EX2 5AZ, UK
Tel: (+44) 1392 797680
Email: enquiries@fwmedia.com

ISBN 13: 978-1-4403-4847-1

Edited by Tonia Jenny
Designed by Geoff Raker
Production coordinated by Jennifer Bass

Photography by Julia Lynn Photography
julialynn.com

About the Authors

FAITH EVANS-SILLS is a painter, wife, mother and teacher making her home in sunny Charleston, South Carolina. To fulfill their dream of living and painting by the sea, after fifteen years in New York City, Faith and her husband fell in love with the South Carolina coast and moved their family there in 2011. In her work, Faith draws inspiration from nature's wild and small moments, love, textiles and most importantly the relationships that shape her. Classically trained in painting with a BFA from Skidmore College and an MFA from Parsons School of Design, along with over twenty years of personal painting experience, Faith enjoys inspiring others to manifest their most heartfelt ideas through creating art. Her art has been exhibited widely and included in multiple publications, and she offers art retreats for women, both in the United States and internationally. Faith lives with her husband, Frank, and their three young children by the sea, where they enjoy exploring southern beaches and maintaining a close connection with nature through frequent trips to wild places. Learn more at faithevanssills.com.

Photo by Gray Benko

MATI ROSE MCDONOUGH is an artist and daring adventurer whose name is pronounced Matey, like *Ahoy!* She grew up near the sea in Maine and now lives in the Bay Area. After wanting to be an artist for many years but feeling like it was "impractical," at age twenty-nine, Mati took the leap and went back to art school at the California College of the Arts. Now over ten years later, she is still excited and terrified every time she sees a blank canvas, but embraces the adventure of life as an artist—penning her first book with this philosophy called *Daring Adventures in Paint.* She has had dozens of art shows and taught painting classes internationally in Italy, Morocco, Costa Rica and more to come! Her illustrations grace all sorts of exciting products from camera cases to giant elephant billboards, as well as her own home décor line and dress line, too—dreams come true! She is pinching herself after all those years that she is making her living as an artist. Mati has illustrated four children's books, including *i carry your heart,* written by poet ee cummings. Through her workshops, books and popular online course, she spreads a warm message of creative courage: It's never too late to show the world your magic. See more at matirose.com.

Photo by Andrea Scher

Ideas. Instruction. Inspiration.

Receive FREE downloadable bonus materials when you sign up for our free newsletter at ClothPaperScissors.com.

Find the latest issues of *Cloth Paper Scissors* on newsstands, or visit shop.clothpaperscissors.com.

These and other fine North Light products are available at your favorite art & craft retailer, bookstore or online supplier. Visit our websites at artistsnetwork.com, interweavestore.com and artistsnetwork.tv.

Follow ClothPaperScissors for the latest news, free wallpapers, free demos and chances to win FREE BOOKS!

Get your art in print!

Visit **artistsnetwork.com/category/competitions** for up-to-date information on *Acrylic Works* and other North Light competitions.